PORTRAITS OF COURAGE

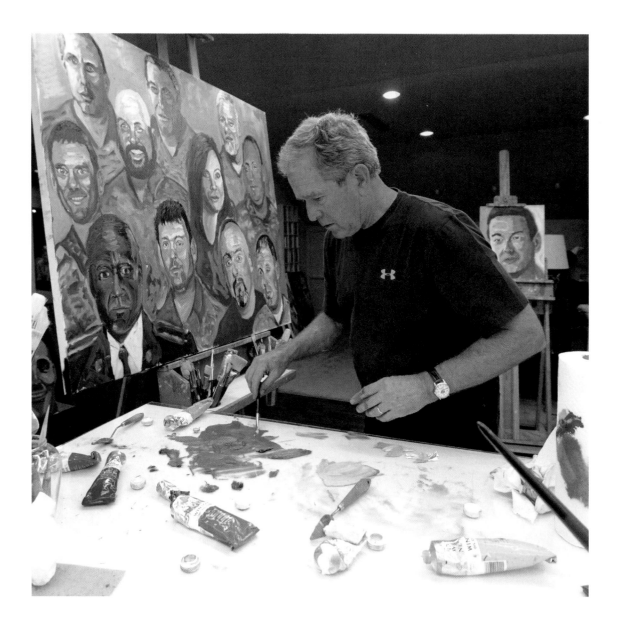

PORTRAITS
OF COURAGE

A COMMANDER IN CHIEF'S TRIBUTE
TO AMERICA'S WARRIORS

GEORGE W. BUSH

CROWN PUBLISHERS
NEW YORK

ALSO BY **GEORGE W. BUSH**

Decision Points

41: A Portrait of My Father

––––––––––

ISBN 978-0-8041-8976-7
ebook ISBN 978-0-8041-8978-1

Printed in the United States of America

Book and jacket design by Marysarah Quinn
Jacket paintings by George W. Bush
Jacket photographs by Grant Miller

FIRST EDITION

5 7 9 10 8 6 4

DEDICATED TO

THE MEN AND WOMEN

OF AMERICA'S ARMED SERVICES

PAST, PRESENT, AND FUTURE

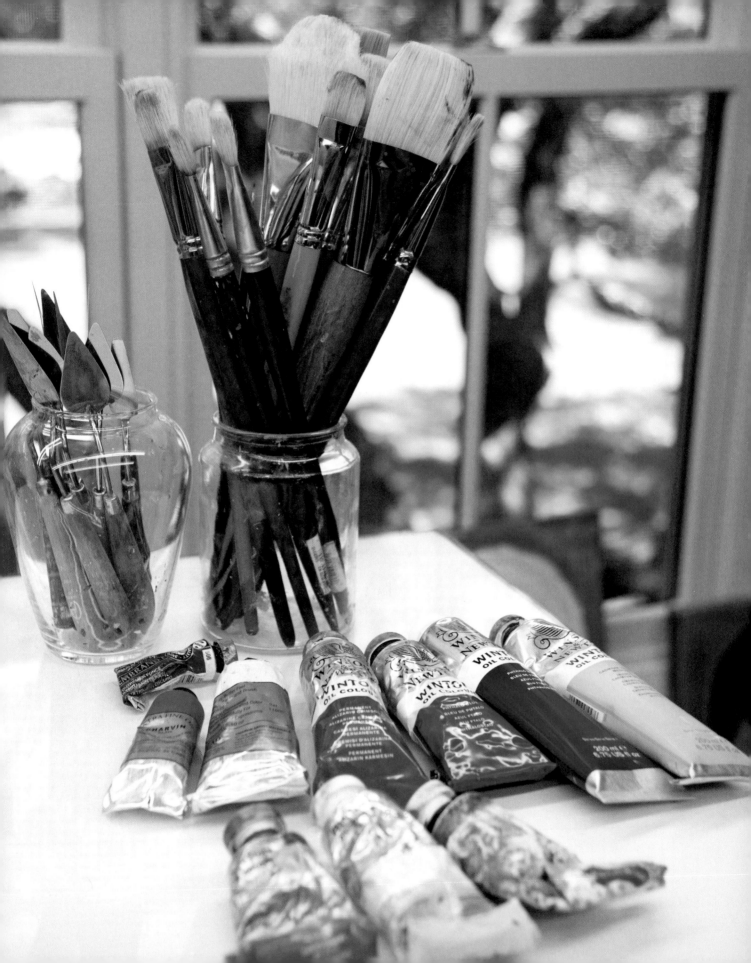

CONTENTS

FOREWORD
BY LAURA BUSH
8

FOREWORD
BY GENERAL PETER PACE
10

PAINTING AS A PASSION: AN INTRODUCTION
BY GEORGE W. BUSH
12

PORTRAITS OF COURAGE
17

MURAL OF AMERICA'S ARMED FORCES
FOLLOWS PAGE 95

INDEX
176

THE MEN AND WOMEN IN THE MURAL
AND THEIR STORIES
181

ACKNOWLEDGMENTS
190

THE GEORGE W. BUSH INSTITUTE'S
MILITARY SERVICE INITIATIVE
192

FOREWORD

LAURA BUSH

FIRST LADY OF THE UNITED STATES, 2001–2009

When George and I married, if someone told me that he would become President, I would have thought, "Well, maybe." He was running for Congress at the time, and we loved politics. But if someone said, "One day you will be writing a foreword for a book that includes George's paintings," I would have said, "No way."

Painting, even as a pastime, is serious business. Like any skill, it takes practice and discipline, which makes it well-suited to George—or, more to the point, George well-suited to it. George is disciplined and project oriented. He gets his work done, and he brings that dedication to painting. He works a few hours every day in his studio.

Every new painter, even a former President, finds himself asking the question: what or whom should I paint? At the beginning, George specialized in portraits of our pets. They didn't mind posing for him, and their feedback consisted mostly of wagging tails or purring. Bob, our cat, was an especially willing subject, assuming a pose and then promptly taking a nap.

But as much as George liked painting pets, he wanted to challenge himself. He began painting humans, even doing a few self-portraits. He thought of the people who had left lasting impressions on him. When he met with them, he didn't have a sketchpad in hand. He wasn't thinking about character studies or light or shadow. Yet in the hours and days they had spent together, he had studied them from a unique vantage point.

Each of the remarkable men and women featured in this book is someone George knows. George painted them from his perspective, as an artist who was once their Commander in Chief. I've seen him with these

men and women, at the bike rides and golf tournaments our Institute hosts for wounded warriors. I've seen him with them in military hospitals, or in back rooms for private visits after speeches. I've seen George make good on his pledge to devote the rest of his life to helping them.

Recently, George was looking through a book of paintings and pointed out a piece by Thomas Moran, saying how much he liked it. I said, "We had a painting by Thomas Moran hanging just outside the Treaty Room at the White House." George had passed that painting nearly every night, when he went into the Treaty Room to continue working after dinner, but he never noticed it. His attention was elsewhere. Our country had been attacked, and as a wartime President, he received casualty reports every day from the front lines. His thoughts were with the troops on the battlefield, the families of the fallen, and the wounded warriors in hospitals around the world. Art was the last thing on my husband's mind.

George and I are forever thankful for the brave men and women who volunteered to defend our country, who risked their lives, and too often gave their lives, so that the rest of us might never know terror again. We are thankful for the nation that allowed us to serve it for eight years. And I am grateful that, at last, George has a chance to develop his artistic eye.

FOREWORD

GENERAL PETER PACE

UNITED STATES MARINE CORPS (RETIRED)

SIXTEENTH CHAIRMAN OF THE JOINT CHIEFS OF STAFF

This book is a collection of portraits of our nation's heroes. Some of their faces are well known, some not so familiar—yet we recognize all of them by their character, and we admire their willingness to defend the freedoms we all hold dear.

True heroes do not consider the title appropriate; more often, they will describe their actions as "just doing my job." But it is precisely this attitude that makes us understand that they really are heroes. With a full understanding of the risks involved, the men and women in this book raised their right hands and served their country with incredible courage and selflessness. Facing multiple deployments, they remained focused and steadfast, choosing to be part of something bigger than themselves. It is our privilege, and our responsibility, to acknowledge their service and their sacrifice.

This collection of portraits provides a closer view of just a few of these heroes. I believe it both honors their service and demonstrates our gratitude as a nation, so that every future generation of our military knows that America values their courage, character, and sense of duty.

Serving behind the scenes are the families of these heroes, who continue to offer quiet strength and untold support. Our military families serve this nation as much as anyone who has ever worn a uniform, and while we may not see their faces in this book, we recognize their presence in each of these portraits and offer our eternal gratitude.

As Vice Chairman and Chairman of the Joint Chiefs of Staff during President George W. Bush's time in office, I had the opportunity to watch our forty-third Commander in Chief in action—not just while

the cameras were rolling but also behind closed doors, during count-less meetings about national security and the ongoing combat operations in Iraq and Afghanistan. In these meetings, President Bush asked tough questions—and continued to ask them until he had all the information he needed to make the myriad difficult decisions he faced. Then, once he made a decision, he would resource it properly and do whatever it took to support those he had charged with carrying it out. As a military man, you couldn't have asked for a better Commander in Chief.

Many times over, President Bush demonstrated he was a man of char-acter, one who valued integrity over popularity. Without fanfare, he and his incredible First Lady visited the wounded and the families of the fallen. Their actions—both in the White House and in the years since—demonstrate a genuine devotion to our military, and the book you hold in your hands is an example of that continued devotion.

Each of these portraits, and the stories that accompany them, is the result of untold time and emotion; each reflects the subject's depth of service and the depth of the artist's care for his troops. They capture the essence of a warrior's spirit, the camaraderie, military ethos, sacrifice, and resilience that mark our men and women in uniform. And as you turn the pages of this volume, I believe you also will come to see a message of love—from a Commander in Chief to his troops.

PAINTING AS A PASSION

AN INTRODUCTION

GEORGE W. BUSH

In March 2012, John Lewis Gaddis, a distinguished professor at Yale, was in Dallas promoting his Pulitzer Prize–winning biography of George Kennan. He came by my office to visit. We talked about his book as well as my Presidential memoir, *Decision Points*. At one point, he told me that he had his students read Winston Churchill's essay "Painting as a Pastime." I decided to read it because of my admiration for Churchill—and because even though I was active, I was antsy. I figured that if painting had sated Churchill's appetite for learning, I might benefit from it as well.

I've been plenty busy since leaving the White House. I've written two books. Laura and I travel frequently, giving speeches and raising money for the George W. Bush Presidential Center. Much of our time is dedicated to the programs and initiatives of our policy institute there. I took up golf after a six-year hiatus. I stay in shape on the mountain bike trails in Dallas and on my ranch. Lately, Laura and I have reveled in the joys of grandparenthood. But despite all of these pursuits, my life didn't seem complete. I wanted a new adventure—within the confines of the post-Presidential bubble.

I told Laura and our artist friend Pam Nelson that I might like to take up painting. They were surprised—I had been an art-agnostic all my life. Laura said, "You ought to try it." It seemed like she was slightly skeptical. Pam suggested I hire her friend Gail Norfleet, a notable and talented Dallas artist, as my instructor. Several days later, Gail came over to the house and asked me what my objectives were. "Gail, there's a Rembrandt trapped in this body," I told her. "Your job is to liberate him."

Soon, I was painting in my makeshift art studio—a room Laura had previously dubbed my "man cave." On our first session, Gail reached into her purse, pulled out a cube, and said, "Paint this."

"Uhhh, what color?" I asked, resorting to an old grade-school stalling tactic.

"Just paint the cube, George," Gail said, dispensing with any Presidential pleasantries and confirming that I'd found the right personality to instruct me.

For the first time in my sixty-six years, I picked up a paintbrush that wasn't meant for drywall. I selected a tube of white paint and another labeled *Burnt Umber*. While I wasn't aware at the time that it was a color, I liked the name, which reminded me of Mother's cooking.

After a few fits and starts, and a lot of hesitant brushstrokes, I painted what actually looked like a cube. I was exhilarated. After dinner, I painted a watermelon. Then an apple. I've been painting ever since. From that point forward, I became a student of art. I wanted to learn as much as I possibly could about painting, perspective, light, and color. I took an online course from the Museum of Modern Art about art history. I studied artists such as Lucian Freud, Wayne Thiebaud, Joaquín Sorolla, Jamie Wyeth, Ray Turner, Fairfield Porter, and the impressionists. In our weekly sessions, Gail encouraged me to paint what I liked. I love animals, so I painted pets. I love our ranch, so I painted landscapes. Before long, I started to see the world differently. Shadows became colors. Once-clear skies had subtle shifts of color. I was getting comfortable with the concepts of values and tones.

At one point, Gail introduced me to her mentor, the respected Dallas artist Roger Winter. Roger came to my studio, looked at some of the paintings, and suggested that I paint world leaders with whom I'd served. I was flattered that Roger thought I could do it and was intrigued by the notion. As far as I knew, no other President had painted world leaders. I collected photos and started sketching my contemporaries' faces onto canvases—intricately measuring the eyes relative to the nose, the mouth, the placement of the ears. I enjoyed the challenge of painting the human

form and trying to capture a person's spirit with brushstrokes. And over the course of many hours of work, I painted the portraits of Putin, Blair, Koizumi, Karzai, the Dalai Lama, and some twenty-five others.

After a couple years, Gail suggested I find another instructor who could help me on my journey to be a better painter—something only a great teacher would suggest. I became a student of longtime Texas Christian University art professor Jim Woodson, an excellent Texas painter and patient instructor. In one of our first sessions, Jim asked what I'd like to focus on. I said color. He convinced me to limit my palette to two reds, two yellows, phthalo blue, and white, and I learned to mix colors from the primaries.

Under Jim's tutelage, I painted series of cacti, water lilies, hats, and more. Jim encouraged me to use larger canvases, larger brushes, and larger amounts of paint, a technique known as impasto. I am fortunate that Jim came into my life—but he spends six months a year at his place in New Mexico, near where Georgia O'Keeffe painted.

I'm driven to learn as much as I possibly can before I'm no longer able to hold a paintbrush. And I know that in order to learn, not only must I paint a lot, but I must listen to those who have excelled in the pursuit. So when Jim headed west in 2015, I asked a young painter named Sedrick Huckaby, who was honored in the National Portrait Gallery's Outwin Boochever Portrait Competition, to join me. I had seen his work at a local gallery and was very impressed. He is a superb painter. Thankfully Sedrick agreed to help me, and thus began my third relationship with a talented artist.

Sedrick told me he was aware of my world leaders series, and he suggested I paint people whom I knew but others didn't. Instantly, I thought of painting wounded warriors I had gotten to know during the W100K mountain bike rides and Warrior Open golf outings put on by the Bush Institute. And so in September 2015, I started painting the ninety-eight men and women who are featured in this book.

I studied the stories and photographs of the warriors. As I painted them, I thought about their backgrounds, their time in the military, and the issues they dealt with as a result of combat—many from visible inju-

ries, others from invisible wounds such as post-traumatic stress (PTS) and traumatic brain injury (TBI). Most of the paintings are closely cropped portraits that I hope give viewers a sense of the remarkable character of these men and women. I wanted to show their determination to recover, lack of self-pity, and desire to continue to serve in new ways as civilians. Some of the paintings are of wider scenes. I wanted to reflect the energy of an amputee playing golf, the camaraderie that these brothers and sisters in arms feel for one another, the power of a loving relationship between husband and wife.

I painted these men and women as a way to honor their service to the country and to show my respect for their sacrifice and courage. I hope to draw attention to the challenges some face when they come home and transition to civilian life—and the need for our country to better address them. At the Bush Institute, our Military Service Initiative is focused on these issues, and the net proceeds from this book will be donated in support of our work.

I'm not sure how the art in this volume will hold up to critical eyes. After all, I'm a novice. What I am sure of is that each painting was done with a lot of care and respect. This is more than an art book. This is a book about men and women who have been tremendous national assets in the Armed Forces—and who continue to be vital to the future success of our country. This is a tribute to men and women who volunteered, many in the years after 9/11, to defend our country. The greatest honor of the Presidency was looking them in the eye and saluting them as their Commander in Chief. And I intend to salute and support them for the rest of my life.

PORTRAITS
OF COURAGE

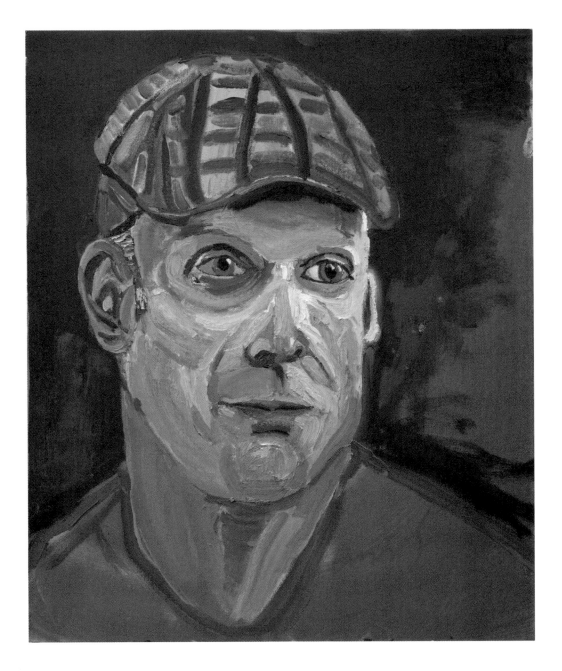

SERGEANT MAJOR
CHRISTOPHER SELF

UNITED STATES ARMY RESERVE, 1984–1986

UNITED STATES ARMY, 1986–2013

———————————————

"Since I was about five years old I wanted to be
a soldier, and that desire never changed."

I first met **CHRIS SELF** in 2009 at the Center for the Intrepid, a rehabilitation center for injured military members in San Antonio. My Presidency had ended just a couple months earlier, and Laura and I were living at our ranch in Crawford a few hours away.

Walking through the Center, I saw a mountain bike and asked whose it was. Sergeant Major Chris Self came forward to claim it. An Army Special Forces amputee, Chris was there to have a new cycling prosthesis made. We talked about biking, and I suggested Chris come ride with me at the ranch. (Well, I sort of challenged him to.) "I'm a good soldier, sir," he said. "You say when and where. I'll be there." Three days later, Chris and his wife, Dana, showed up, and he rode me into the ground with one leg. My day with Chris was so inspiring that I decided to host an annual bike ride for wounded vets, the W100K. At the time, I thought it would be a fun way to spend time with them and show my thanks. Over the years, it would become a major networking and healing opportunity for our veterans, the catalyst for the Bush Institute's Military Service Initiative, and one of my favorite events of the year.

Chris's Army career began in 1984. "Since I was about five years old I wanted to be a soldier," he says, "and that desire never changed." Chris deployed to Turkey once, Afghanistan once, and Iraq an astonishing six times—two of which were after his leg was amputated. The injury happened in northern Baghdad in December 2005. "I was shot in a funny little incident," Chris puts it dryly. Approximately fifteen Iraqi prisoners had just escaped when Chris ran across them. "I made a stand at the gate with two Puerto Rican national guardsmen and five of my Iraqi counterparts. During the close combat, I was shot once in each leg." The left leg was paralyzed. "After six months of neurology and physical therapy, I had the leg amputated so I could run, jump with Airborne status, and continue to serve."

Before his injury and amputation, Chris had been in great shape thanks to running, cycling, swimming, triathlons, and weight training. When he got home, he learned about Operation Rebound, a program put on by the Challenged Athletes Foundation that helps injured service members and first responders get moving again. They gave Chris the equipment

and resources to get back into the activities he loved. "Those same activities took on a recovery role and shortened the recovery time," he says.

They also helped with another aspect of Chris's recovery. "You know, when I first got wounded, you kind of go through the depression stage," he says. But seeing others in his situation perform in peak physical condition motivated Chris to do the same. And just eight months after his amputation, he was back to jumping out of airplanes. "It gave me the confidence that I would be able to stay on active duty and return to the fight," he says.

Too often, the contributions of military spouses go unnoticed. Not so with Chris, who honors his wife Dana's service and sacrifice. "She was the core of everything that had to do with my recovery. It is an ongoing process even today. With the awesome support of my family and caregivers, including my beautiful wife and daughters, Jordan and Haley, and the emotional support from my son, Reese, the intense process was fairly smooth. We were honored to serve six more years after the amputation," Chris says.

For my seventieth birthday in 2016, I invited Chris and a few other wounded warriors to come ride with me at the ranch. Chris, ever the character, showed respect for his elder by wearing a tuxedo cycling jersey—complete with a bow tie. To preserve his sartorial shenanigans for posterity, I painted my pal in his goofiest-looking hat.

MASTER SERGEANT
SCOTT NEIL

UNITED STATES ARMY, 1986–2010

Scott Neil grew up on cattle ranches in Florida, predisposed to the life of a cowboy. "After watching the movie *Green Berets,*" starring Hollywood's cowboy John Wayne, "I knew that I wanted to earn my Green Beret," Scott says.

During his twenty-four-year career in the Army, Scott conducted Special Forces missions in Kenya, Kuwait, Saudi Arabia, Pakistan, Oman, and Yemen. Immediately following 9/11, he deployed to Afghanistan as one of the first Green Berets in. He went on to Iraq for three rotations, then to Africa in pursuit of foreign fighters there. "Intense combat operations were almost nightly," Scott recounts, and the fighting took a toll on his mind and body. After an IED (Improvised Explosive Device) attack on his vehicle in Iraq in 2004, Scott started to notice the symptoms of TBI and deteriorating vertebrae in his neck.

Early in the war, the national knowledge of and conversation about TBI and PTS were limited. Scott turned to other Special Forces vets for advice on how to cope with what he describes as "the tendency to be angry and distant every day." Eventually, he learned that the outdoors provides the best therapy for him.

In 2016, I received a picture of Scotty in a cowboy hat flashing two thumbs up. He looked like John Wayne, but bearded and in better shape. He was on a trip with a fellow wounded warrior and their families. "The greatest adventure was a ten-day, hundred-mile horse-and-pack train through the Thorofare of Yellowstone," Scotty wrote. "I hadn't ridden a horse since my childhood."

Today, Scotty is in a good place. "I am through the hate 'tunnel' and on the other side and enjoying being a great American," he says. I think 'ole Duke would agree with that assessment. Scott's latest project has been consulting on a documentary film titled *The Legion,* about the American Special Forces who led the first charge into Afghanistan after 9/11— while mounted on horses.

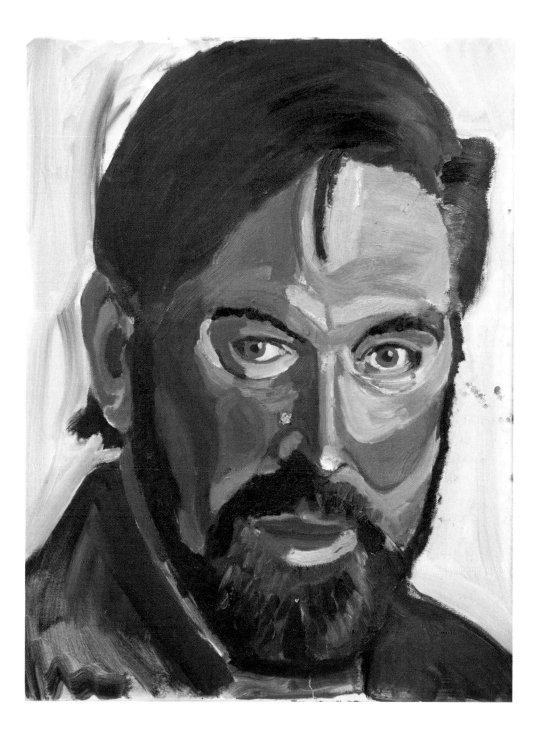

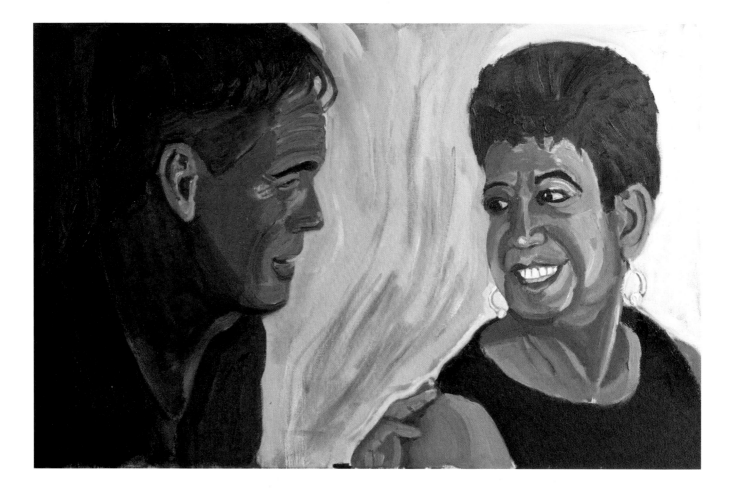

ROQUE URENA

"I say *we* served twenty-five years," Roque Urena's wife, Marlene, explains. "I lived every deployment with Roque. Every trial and tribulation. The day I said 'Yes' to him, I really didn't realize the impact it was going to have. We are together because of our love, but I was almost lost at one point."

Marlene's husband was a medic in the Air Force for twenty-five years. "Everyone calls me Rocky. For some reason they can't pronounce Roque," he jokes. Rocky was born in the Dominican Republic and grew up in New York City. "I joined the Air Force because I wanted to travel the world and at the same time serve the country that became part of my life.

"We deployed to Iraq in August 2004," Rocky says. "That first night, we just got hit with multiple casualties. IED, gunshots, sniper wounds, holes through the head, brain matter. It's not pretty." Over the next few months, Rocky would treat more than 3,500 injuries as a shift leader in the emergency room. "In the ER, you don't think about it—you just do what you have to do. But afterwards, in the aftermath, after the storm— that's when you start processing.

"It was total chaos," Rocky says, holding back tears. "It stays with you."

When he came home, Marlene and their daughter, Alyssa, could tell something was wrong. Rocky kept to himself. He didn't want to burden his family with what he saw, and he didn't think they could understand. "Marlene asked me one time, 'Why do you cry?'" he remembers. "I said, 'I don't know, it just happens.'"

In early 2013, a fellow veteran who knew Rocky was struggling told him about the mountain bike ride we host for wounded veterans. Rocky came and rode like the wind. And slowly, after healing so many others, he is starting to heal himself.

"Life has sometimes been a little rough since Rocky came back the second time from Iraq," Marlene wrote me in 2013. "But we would not do anything differently if we had to do it over again."

LESLIE ZIMMERMAN

At the end of a long ride in 2015, I was tired, but some of the other sixteen riders in our group weren't. So I asked, "Anyone want to climb one of our toughest tracks?" The next thing I knew, Leslie Zimmerman, with red locks streaming out from behind her helmet, went charging up the hill.

Leslie has always been a hard-charger. She joined the Army at age eighteen, right out of high school. "I just thrived in the military," she says. "Within three years I was a sergeant, and I loved every minute of it."

In 2003, Leslie staged in Kuwait and then deployed to Iraq in support of Operation Iraqi Freedom. As a medic, she witnessed the brutality of war. She doesn't say much about it, other than "I am proud that I deployed to Iraq and was able to save lives."

When Leslie came home, she was diagnosed with PTS and depression. Everything felt different. Her energy and motivation, normally at the top of the charts, barely registered. She was sad and anxious and couldn't sleep, plagued by flashbacks and night terrors. She withdrew from social environments, including that of her own family.

"It took losing a marriage and pushing away from close friends for me to realize I couldn't do this on my own," she says. Leslie sought counseling and medication, supplementing those treatments with mountain biking, long-distance running, and coaching. Eventually, she remarried. "Judd pushes me to get out of the house on the days when I am completely overwhelmed with grief and heartache. My three children have helped also," Leslie says.

Leslie came back to the ranch for the ride on my seventieth birthday. She brought Laura and me a signed first edition of *Dream BIG!,* the children's book she recently wrote, to give to our granddaughters, Mila and Poppy Louise. As a grandfather who's already head over heels for our daughter's girls, I'll be pleased if they come to count Leslie as a role model.

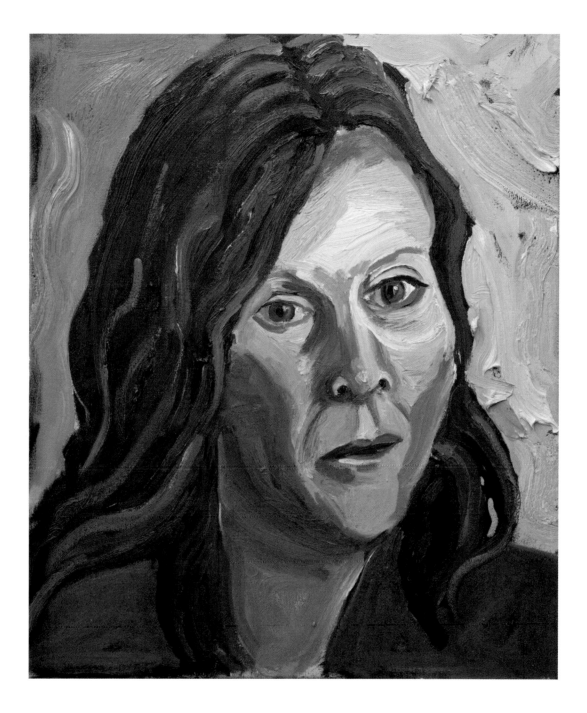

SCOTT P. LILLEY

Marine One touched down on the South Lawn on a beautiful Sunday in May 2007. As I walked into the White House, I worked the rope line of guests who had come to see the arrival. It was there that I met Frank and Jolene Lilley of Roswell, New Mexico. They told me that their son, Scott, was at the military hospital nearby in Bethesda with serious head injuries from an IED attack. I was moved by the concern on their faces and asked the White House physician, Air Force General Dick Tubb, to check on Scott's condition. He reported back that Scott was not expected to live.

Two months later, I saw the Lilleys again. Laura and I had invited them, as well as other military and veteran families, to the Fourth of July celebration on the South Lawn. To my surprise, Scott was there with them. He was still in bad shape, missing a large part of his skull and obviously hurting. I kept tabs on Scott for the remainder of my Presidency, inviting the Lilleys in for a visit to the Oval Office and to the East Room for my White House farewell address.

Years later, at my office in Dallas, I reviewed the list of veterans participating in our Institute's first golf tournament for wounded warriors. I was shocked and delighted to see Scott Lilley's name. I didn't know what kind of a golfer he would be, but I knew he was one heck of a fighter if he'd recovered enough to play.

Scott had a tough day on the course, but his spirits were strong. After all, he'd been through a lot worse. To this day, a piece of shrapnel is still lodged in the left side of his brain, affecting his short-term memory. Scott's attitude? "It's not the end of the world. Keep a smile on your face. New doors will open and guide you in the right direction."

Shortly after returning for the tournament in 2015, Scott called and asked me to meet a special person. A few days later, he introduced me to his young daughter, MiKaylie Rayne Lilley. As I painted the proud father and daughter together, I thought about Scott's brush with death and the new life born from his perseverance.

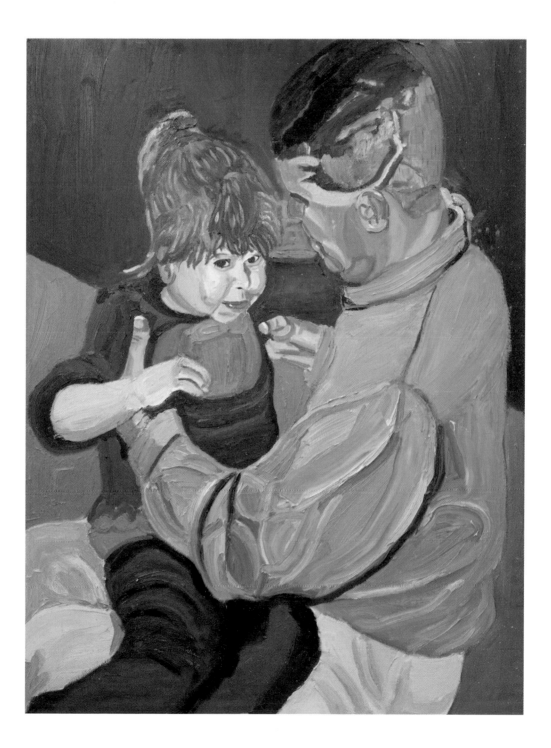

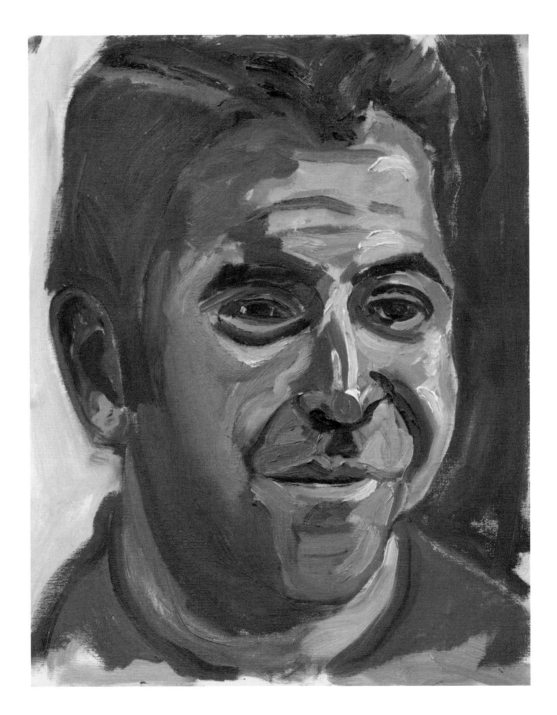

JUAN CARLOS HERNANDEZ

UNITED STATES ARMY, 2006–2011

———————————————

"I wanted to be a part of something bigger than myself and do something
I would forever be proud of. But for me, the main reason was to give back
to the country that had done so much for my family and me."

JUAN CARLOS HERNANDEZ was born in Orizaba, Mexico. At the age of nine, his mother brought Juan and his two brothers to the United States so they could build better lives than she'd had. "Unfortunately, we didn't have papers, so we crossed the border illegally," Juan says. "I was terrified. I didn't speak a single word of English, and I knew nothing about this place I would come to love and call home."

After graduating from high school in Schulenburg, Texas, where he was on the football and powerlifting teams, Juan decided to join the Army. "I wanted to be part of something bigger than myself and do something that I would forever be proud of. But for me, the main reason was to give back to the country that had done so much for my family and me," he says.

Juan deployed to Afghanistan as a door gunner on CH-47 Chinook helicopters. On a nighttime mission flying low through the valleys in 2009, a rocket-propelled grenade (RPG) hit his team's chopper near the fuel tank. Juan lost his right leg in the attack.

He recovered at Brooke Army Medical Center, where he was fitted with a prosthetic leg. He started walking again in just three months. That was the easy part. The hard part was feeling isolated from the people he interacted with each day. "The fact that there is such a separation between those who serve and those who don't is scary." He says he enjoys being around children, whose innocent, curious minds prompt them to ask Juan about his injury. Most adults just stare at him.

Juan describes one of the most widespread misperceptions civilians have about veterans: "A soldier does not miss war. They miss the people they were with, the friendships, the bond that comes from experiencing the same events with them." He found that the military service organizations that help wounded warriors network with each other really helped. "It's just heartwarming that you have these organizations that come out and help you with support from the American people," he says. "I would probably still be moping around in my house, not wanting to do anything, if it weren't for the support of my brothers from the military who come along on these mountain bike rides and talk about everything we've been through and how to make things better."

Juan was deeply moved by the care and support he received throughout his journey—so moved, in fact, that he is now pursuing his undergraduate degree in kinesiology. "I realized that my chapter in the military had been completed, and it was time to write a new one," he says. After being on the receiving end of life-changing and lifesaving physical therapy, Juan wants to pay it forward. "I would love to work with children who struggle with disabilities and make their lives better."

Juan is a selfless soul with a servant's heart. He is proud of and grateful for the opportunity to have served this country—*his* country. "That's my payback. That's my way of saying thank-you. And I wouldn't trade it for anything in the world," he says. He became an American citizen in May 2009—at Bagram Airfield in Afghanistan. Juan's story is one example of the countless ways that immigrants make America great. And I am honored and humbled to call Juan Carlos Hernandez my fellow citizen.

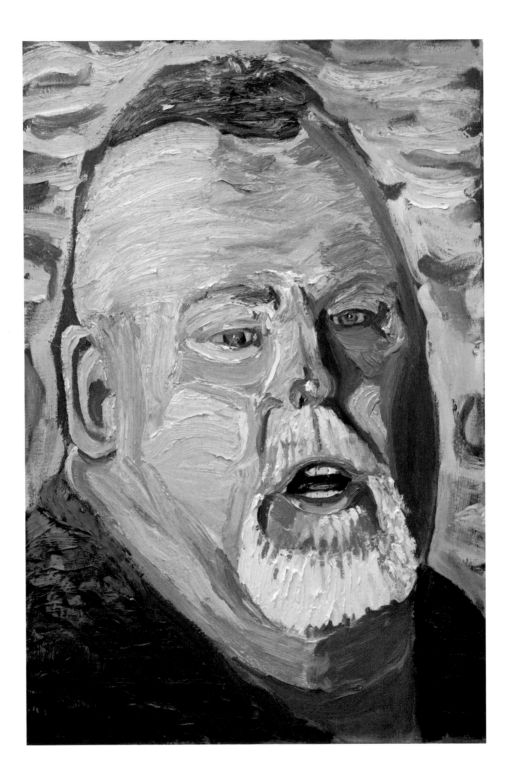

SCOTT ALAN ADAMS SR.

When Scott Adams hit a less-than-perfect tee shot at the Bush Institute's Warrior Open, the gallery groaned, "Ahhhh."

I wanted to comfort him, so I shouted, "Come over here, big boy!" and gave him three huge belly bumps. It wasn't the most Presidential thing I've ever done, but we both had a good laugh.

For twenty-two years, Scott was responsible for logistics in the Army. In January 2007, on his fifth deployment, his vehicle hit two antitank mines laced with white phosphorus, a chemical compound that causes horrific burns. Scott was knocked unconscious, his vehicle blown six feet into the air. When he came to, he was trapped inside.

Scott's team pulled him out of the vehicle. He was engulfed in flames. "I began screaming and running," he says. Having been a volunteer fire-fighter back home, Scott remembered to stop, drop, and roll—but every time he rolled, he would light up again. Once the flames were finally extinguished, Scott was airlifted to Germany. He woke up a month later at Brooke Army Medical Center with multiple injuries. His recovery took more than eighteen months. Fortunately, Scott says, he had a lot to live for—especially his wife, Susie, and their four children.

Scott understands that his real recovery will be a lifelong endeavor. He struggles with post-traumatic stress. He has nightmares and night sweats. When he's in a car—at home in the United States—he can't ride in the far-right lane for fear of hitting an IED. Courageously, he seeks treatment for his symptoms at the VA and relies on the support of his family and the therapeutic benefits of golf.

Scott came to Texas for the Warrior Open from his home in Minne-sota, where the cooler climate helps him tolerate his burns. So when he shot an 82 in the 93-degree Dallas heat, I was really impressed.

MATTHEW S. AYERS

UNITED STATES NAVY RESERVE, 2003-2005

UNITED STATES ARMY NATIONAL GUARD, 2005-2010

UNITED STATES ARMY RESERVE, 2010-PRESENT

In 2003, Matt Ayers was a twenty-six-year-old building his future in Ohio. He had a steady job with the Columbus Fire Department. He and his wife, Deborah, had bought a home and were beginning to think about starting a family.

"Then the Iraq theater started," Matt says. "I made my decision immediately. I joined because I knew if I didn't, I would regret it the rest of my life."

Matt started out as a Naval Reservist before transferring to the Army as a combat medic with the 19th Special Forces Group. "The job is hard, doesn't pay well, and the hours are extremely long. But for some reason I can't picture my life without it," he says. "Simply put, it's who I am."

Sergeant Ayers deployed to Iraq in 2006 and Afghanistan in 2010. The next year, he was severely wounded by a misdirected artillery round. The friendly fire rocked him hard: traumatic brain injury, hearing loss, shrapnel to the hip, a torn disk in his back.

Matt recovered from his physical wounds at Fort Knox's Warrior Transition Unit. And thanks to Deborah's urging, he's getting treatment for his invisible wounds of TBI and PTS. Another part of his healing comes from outdoor hobbies like mountain biking, kayaking, backpacking, and fishing—especially when his wife and daughter come along. As Matt puts it, "Family time relaxes me, which melts the stress away and works as therapy."

But this doesn't mean coming home was easy. "Ten days ago, you were diving into a fortified structure, hiding from incoming, hoping not to get killed before your ride home," he says. "Now you're watching the war on TV from your own living room. It's a very bizarre experience. You realize that your part of the war is over. I made peace with the fact that it changed me and understood that I have to move forward."

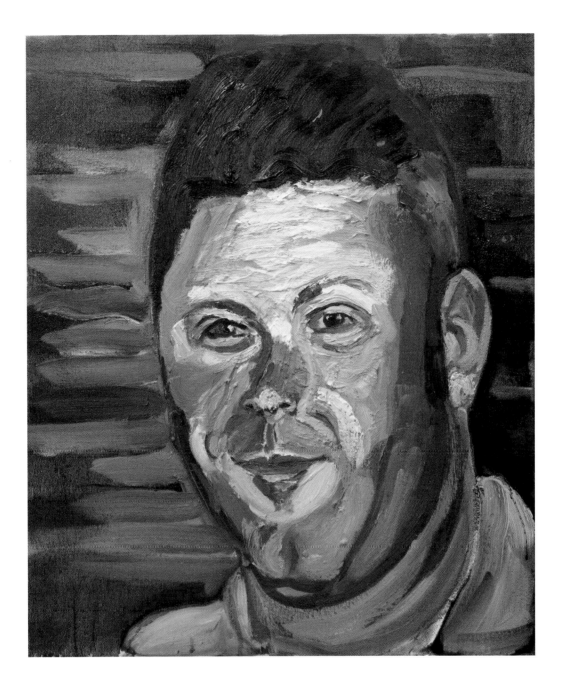

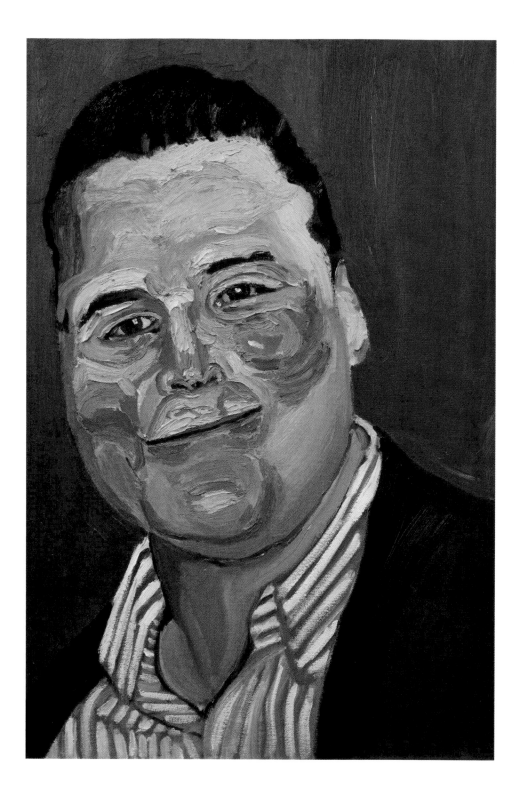

JAE BARCLAY

"I like to say I was born an Army Ranger," says Jae Barclay. "My father served for thirty-six years and retired as a three-star general. I joined the Army in 2004 upon graduating from North Georgia College on an ROTC scholarship. I chose to serve because I grew up surrounded by heroes on a daily basis—the great Army leaders in my family."

Jae has a certain way with words and an irreverent sense of humor I can relate to. "I received my second Purple Heart on August 19, 2006," he says. "It was my one-year wedding anniversary. I like to say it was God's unique way of telling me, 'You're not going to forget your anniversary now, for sure.'"

Jae's vehicle struck an IED in Afghanistan, throwing him thirty feet. Of the five people inside, Jae and the driver were the only survivors. Jae suffered burns on nearly 50 percent of his body. "I spent the next two and a half years at the Fisher House," Jay says, referring to one of the most compassionate and effective military service organizations in existence. "I've had over thirty surgeries just to fix my face, hands, arms, and kind of put Humpty Dumpty back together again," he says. "Now I'm looking like Brad Pitt, and it's all good."

But even with a sunny disposition like Jae's, the transition to civilian life is riddled with challenges. "I thought I was going to be a lifelong soldier," he says. "I had to deal with the fact that I could no longer lead men and do what I loved to do."

Today, Jae has a successful career in the private sector. He's finding his happiness in the family for whom he provides a good living and a great example. "I want to show that I can be a part of society and still contribute," he says. "That's my driving factor."

DANIEL CASARA

Danny Casara is a man of many interests. He started playing the drums at age two. At seven, he fell in love with baseball. He was a biology pre-med student at Xavier University of Louisiana before changing his major to music and liberal arts. Then he joined the Army. He has always loved biking, golfing, baseball, and snowboarding—hobbies he continues to this day. He was the first participant to compete in both my Institute's golf tournament and our mountain bike ride.

What makes that remarkable is that in 2005, an antitank mine flipped Danny's M113 armored personnel carrier in Baghdad, killing two of his teammates and crushing Danny's legs. "Doctors asked me if I wanted them to save my legs," he recalls. "I said, 'Yeah. I came into this world with two legs, and I'm going to leave with two.'" It took twenty-four surgeries to keep them, and doctors weren't sure whether Danny would walk again. "I had to relearn how to walk. The falling, the getting back up—it just became a way of life."

Danny says his recovery accelerated when he began coaching his son's baseball team. "Trying to teach him how to field a ground ball from a wheelchair was frustrating," he says, "so I just pushed myself. And my family, friends, and many nonprofit organizations helped me recover."

In 2014, Danny spoke in front of a large crowd at a dinner we were hosting during the Bush Institute's Warrior Open. He had the entire audience captivated with his story and its lessons. He was so good, I nicknamed him The Preacher. "I realize the power of my message and the gift God blessed me with," he says. "To my fellow brothers and sisters in arms, I say, stay encouraged and never let anyone tell you that your outcome will be determined by your situation. If someone is down, reach out hard to help pull them up. You will heal faster in the process."

Amen.

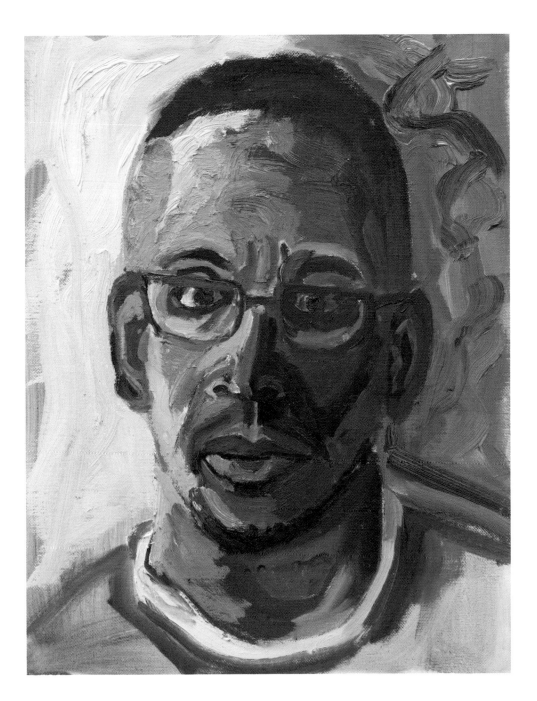

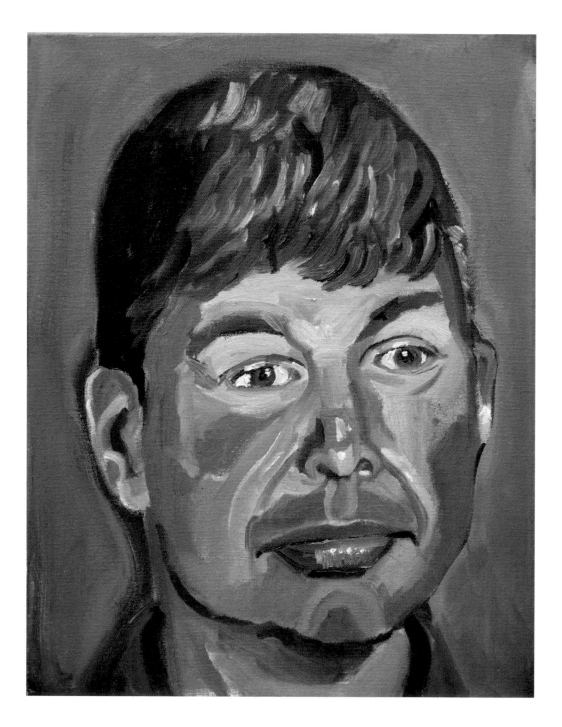

SEAN BENNETT

UNITED STATES ARMY, 1992–2010

I love baseball. So when I heard that Sean Bennett would perform the National Anthem at Fenway Park on July 23, 2016, I was grateful for an excuse to tune in. Sean delivered a stirring rendition; the Sox, on the other hand, left a little to be desired, losing to the Twins 9 to 11.

Sean signed up with the Army when he turned eighteen. "I just felt like serving my country was a duty that I needed to do to become a man, to a certain degree," he explains.

Fourteen years later, he was a decorated soldier on his third deployment to Iraq when insurgents launched a raid on his compound, disguised in purloined American uniforms. Sean describes the harrowing scene matter-of-factly. "It was a pretty grueling day. I was shot in the left shoulder, and I lost five of my best friends and soldiers." What he doesn't say is that he saved others during the ambush by fighting off the attackers, or that in the aftermath of the firefight, he organized medical evacuation for his men—selfless acts that earned Sean the Silver Star.

Nearly two decades in the military had shaped Sean into a mission-oriented man. So when he came home injured, he got right to his recovery (starting with a Tiger Woods video game on Wii, which helped him regain his mobility). Sean believes that the best healing often comes from fellow veterans who have undergone similar experiences. "The military personnel that retire, the veterans, everyone—I think it's their duty to support their brothers and sisters when they get out," he explains. Yet he understands that there's not a one-size-fits-all cure. "I feel like my life now is based off of trying to explain quietly how I recovered, but not giving too much information so they can recover on their own."

To help with this mission, Sean started Band of Heroes with three other veterans. Sean and his fellow musicians entertained Laura, me, and a large gathering at the Bush Center during the 2015 Warrior Open. The patriotic music was uplifting, the performance was strong, and the image of those vets together onstage was moving.

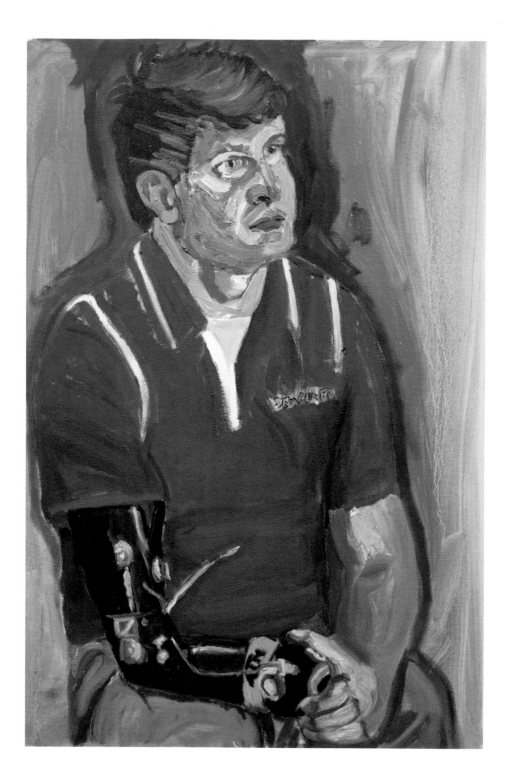

TIMOTHY BROWN

When we received Tim Brown's application for our mountain bike ride, there was some concern among the Bush Institute's staff for his safety. The trails on my ranch can be tough, technical, and rocky. Tim only has one limb—his wounded left arm, which he uses to power a three-wheeled hand cycle.

Tim enlisted in June 2003. "Being a Marine was the only thing I ever wanted to do," he says. He started as a field radio operator before becoming a technician responsible for defusing bombs. On his third combat deployment, Tim stepped on an IED. "The thirteen-pound blast severed both my legs above the knee and my right arm above the elbow, mangled my left hand, and caused extensive injuries," he shares. Tim underwent forty surgeries during his three-and-a-half-year stay at Walter Reed.

We heard that despite his injuries, Tim was a strong rider and a lot of fun to be around. We gave him a slot in the ride. Sure enough, when he got to Crawford, Tim pedaled like a madman. "The bouncier I can get on my mountain bike, the better, and I just had a blast the entire time," he says. His energy and enthusiasm lifted the entire peloton.

At one point in the ride, Tim was approaching a treacherous hairpin turn. Everyone warned him to slow down, but Tim got a devilish grin on his face and sped up. He entered the turn, hit his brakes just right, and slid around the corner. Someone described it as a "Tokyo drift." Whatever that is, I'm confident it was the only time the maneuver has been deployed in Crawford, Texas.

Upon being medically retired in 2014, Tim decided to go back to school to finish his degree. At the time he joined the Marines, he had been at the University of Houston with a GPA of 1.97. He's now studying business at Montgomery College in Maryland. He has a 4.0 GPA.

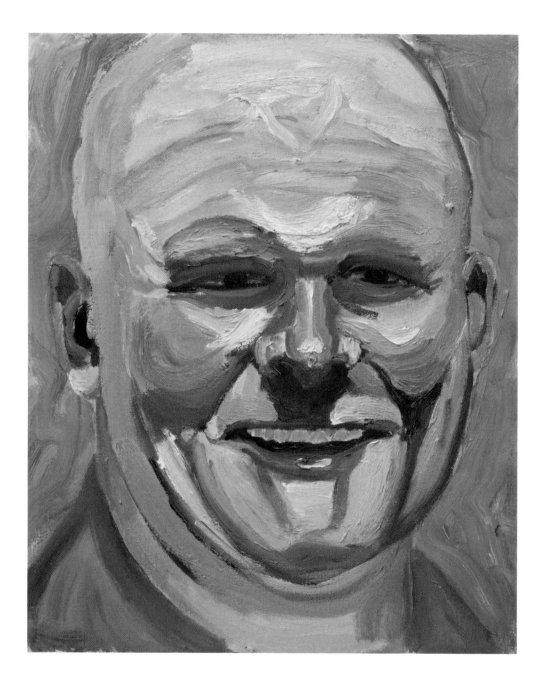

BRYCE FRANKLIN COLE

Bryce Cole felt the desire to wear the uniform for most of his life. "Probably from the time I saw my first Rambo movie," he jokes. His plan was to enlist after completing his law degree, but after his first year at Thurgood Marshall School of Law in Houston, he decided that he couldn't wait any longer. "My entire family had served, and my brother was in Afghanistan."

Bryce returned from his deployment in the Diyala province of Iraq with serious injuries. He tells it without any drama: "I hit a lot of IEDs when I was in Iraq." He had lost the ability to run, so when he got home, he reconnected with one of his previous passions, mountain biking. It helped him heal and get on with his life. He found a good job selling a medical device for robotic surgery, and he loves it. As a beneficiary of good medical care, he says, "It's awesome knowing that my efforts help bring better surgery to many."

Bryce understands what the Bush Institute calls a civilian-military divide—a lack of understanding in our country between those who have served and those who haven't. To bridge that divide, Bryce has simple messages. To civilians, he says, "I'm no different than anyone else. Please treat me the same. My service and injuries don't make me a victim." And to his fellow veterans: "Don't get stuck in the rut of letting your service and injuries define you. You are so much more. Get the help you need and deserve so you can move on."

Bryce has moved on. "I have two awesome boys, Caleb and Cooper, and an amazing wife, Teresa. My goals all really center around being a dad right now."

In my experience, there's no more important job in the world.

ZACHARIAH COLLETT

UNITED STATES ARMY, 2002–2010

I painted Zach Collett with two things in mind. First, how much he had suffered from physical and invisible wounds of war. Second, how honored I was that he had named his son Lincoln Walker Collett for the sixteenth president, Abraham Lincoln, and the forty-third president, George Walker Bush.

Zach joined the Army right out of high school, following in the footsteps of his great-grandfather (World War II), grandfather (Vietnam), and two uncles who served twenty-six years each. "I felt it was my duty and calling to carry on the family legacy," he says.

On Christmas Day 2003, during his first deployment to Iraq, Zach hit an IED. In the years that followed, he lost feeling in his right leg and could barely walk. Then there were the wounds to his brain. "The PTS and TBI have done more damage to me and my life than one could ever wish upon their worst enemy," he says. Zach self-medicated with alcohol and pain medications, trying to find equilibrium. He sought counseling. Nothing seemed to work. He was alienated from his friends and family, including his wife and firstborn child.

Just as Zach's life was spiraling out of control, a military service organization helped him land a job as an intelligence analyst for the FBI. There, he met a fellow vet who convinced him to participate in an Ironman race with him. And, as Zach puts it, he started digging out of the hole he had dug.

Today, Zach has reconnected with the things he loves, starting with athletics. I've seen how well he can ride a mountain bike and swing a golf club. He is studying public policy at Ohio State. And Zach and his wife, Faryn, are raising Jordyn, Kyndi, and of course little Lincoln Walker.

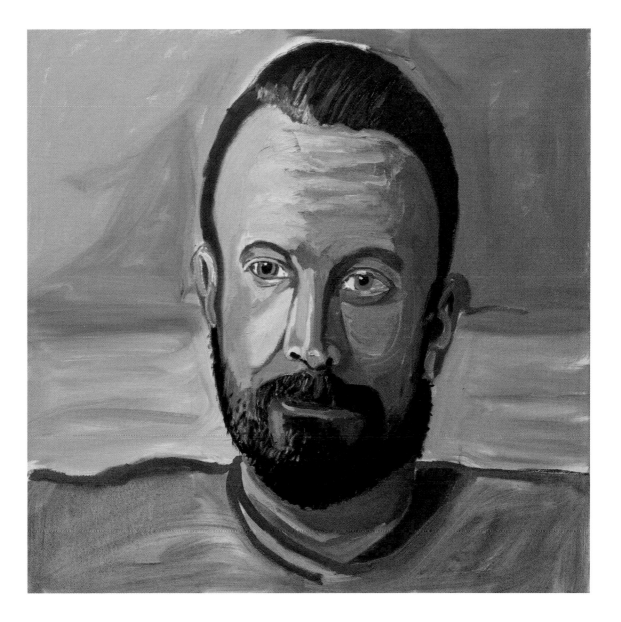

LIEUTENANT COLONEL
KENT GRAHAM SOLHEIM

UNITED STATES ARMY, 1994-PRESENT

The women on my Institute's events team are the best in the business when it comes to putting on events to support our servicemen and women. But at our mountain bike ride in 2013, I noticed they were a little distracted. One of the participants was the dashing Kent Solheim, also known as "Captain America."

Kent not only looks like an action hero; he is one. He joined the Army at age twenty-two, fulfilling a lifelong goal. He has deployed four times to Afghanistan and twice to Iraq—a remarkable sacrifice on its own, before you consider that two of those deployments came after Kent lost his right leg.

In 2007, Kent's Special Forces team came under heavy fire in Iraq, and Kent was shot four times at close range with an AK-47. Two of the bullets destroyed his right leg, forcing it to be amputated below the knee. Thirty-four surgeries later, Kent was back in action.

Colonel Miguel Howe, who runs my Institute's Military Service Initiative, was Kent's commander on a subsequent deployment. One day, Kent came into Miguel's makeshift office south of Kabul and did something unusual: he gave his superior officer marching orders. "You need to go to Kabul National Military Hospital and see what I just saw," Kent told him. "Wounded Afghan soldiers are being subjected to deplorable conditions, and you have to do something about it." Colonel Howe complied.

Kent's service to others doesn't stop when he takes off his uniform. He and his wife, Trina, run Gold Star Teen Adventures, an organization that works with children of those killed on the front lines. Kent says he'll continue to run the foundation as long as the need exists, and he'll continue to serve in the Army as long as he can contribute. He doesn't show any signs of slowing down. Kent just took command of the elite Third Battalion, 3rd Special Forces Group (Airborne).

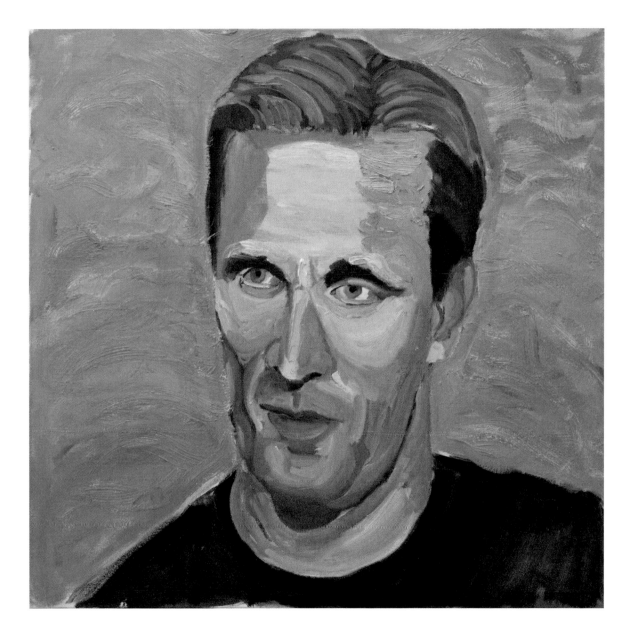

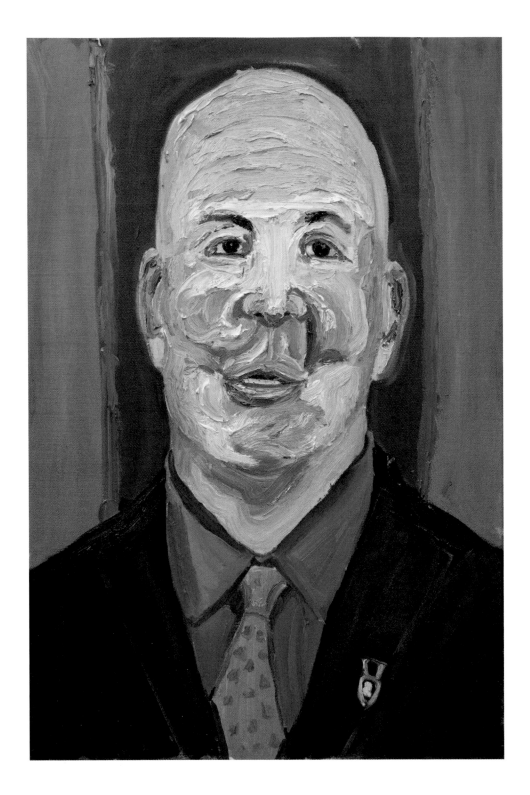

JUSTIN CONSTANTINE

UNITED STATES MARINE CORPS, 1997–2013

———————————

"I can definitely say I am a better person

after what I've been through."

It was October 18, 2006, near Fallujah, Iraq. **JUSTIN CONSTANTINE** and the jump team of Marines he was with knew that an enemy sniper had been operating near their position. "Hey, Jay," Justin warned the reporter embedded with them, "don't forget you need to move quicker here. We don't want you to get shot." As the reporter took a step forward, a sniper round smashed into the wall just behind his head. The next bullet hit Justin behind his left ear and exited through his mouth.

As twenty-four-year-old Navy corpsman George Grant rushed to Justin's aid, a nearby Marine shouted, "Don't worry about the Major. He's dead." Grant disregarded him. As the sniper continued to fire, he performed rescue breathing and an emergency tracheotomy on Justin. He saved Justin's life.

Justin lost vision in his left eye, most of his teeth, and the end of his tongue. Talking and eating can be difficult for him. He can't run, because bones were removed from his legs to reconstruct his jaws. Traumatic brain injury and post-traumatic stress add to his challenges and can manifest in cruel ways. "I was embarrassed when I woke up in the hospital and I knew my Marines were still fighting in Iraq," Justin says. "I struggled greatly with a form of survivor's guilt from coming home early from my deployment. For me, it was mission failure.

"For several years after I was shot, my head and face were horribly disfigured, and walking outside in public was embarrassing," Justin says. "But through golf I could escape to beautiful landscapes, alone for hours chasing that ball around the course and not having to deal with the curious stares from strangers." Playing golf helped give Justin the peace to recognize how much he had to live for and to start to improve his well-being. "Through my injury, I realized that life is short and can be gone in an instant. That made me want to excel in everything I did, and to dedicate my time to things that were important to me."

First on that list is his wife, Dahlia. "She has made everything I have achieved possible," Justin says.

Another is giving back through nonprofit military service organizations. "The road to recovery can be very difficult for a lot of us. Many of

us are surviving injuries that would have killed service members in previous wars," he points out, a blessing of modern medicine that presents new challenges. "Don't be afraid to ask for help," he tells his fellow veterans. "There are so many groups and organizations designed to support us, but sometimes we can be embarrassed to reach out to them."

As soon as he was able, Justin returned to his career in the legal profession, where he had worked before enlisting. He has worked for the Department of Justice, the Senate Veterans' Affairs Committee, and the FBI. He earned an advanced law degree at Georgetown University, where he graduated with distinction.

Most recently, Justin started his own business as an author, leadership consultant, and inspirational speaker—no small undertaking for someone who got shot through the mouth and finds it difficult to talk. "I want to be defined not by what happened to me in Iraq," he says, "but what I have done since then." When speaking to an audience, Justin focuses on his areas of expertise: overcoming adversity and what he calls "the upside of change." "I can definitely say I am a better person after what I've been through," he says.

For Jeremy Henderson, the Army was going to be his "ticket out of Edgemont, South Dakota." After growing up in a small town, Jeremy's dream was to venture out into the world. As he puts it, "The military had all the tools that I needed to go out and do bigger and better things in life."

Jeremy's fourteen-year military career took him to bases across the United States and abroad to Germany, Ukraine, Bosnia, Korea, and Iraq. In 2007, on his second tour in Iraq, Jeremy was preparing his platoon for a mission near Fallujah when a mortar exploded fifteen feet away from him. He woke up in Brooke Army Medical Center in San Antonio, Texas. Doctors told him he had a fractured pelvis, a shattered right hip and femur, multiple back fractures, shrapnel wounds across his body, hearing loss, and a moderate brain injury to his frontal lobe.

Jeremy doesn't sugarcoat what followed: "My recovery was a true nightmare." Like so many wounded warriors, Jeremy's saving grace in the years that followed was his closest caregiver—his wife, Tina. "She had to change my dressing, care for my PICC line, and administer six IV bags a day to treat the infections I received from the dirty mortar round. She was my nurse, my medication manager, my advocate, my taxi to my appointments, my secretary who scheduled them, and my life support. She fought for me during the tough times and kept me going."

Jeremy commends the critical role of the military spouse, particularly during times of war. "My hat goes off to the spouses who make it through the process with their warrior," he says. Now that he's back on his feet, his goals are to give back to Tina, his children, and now the grandchildren that he and his wife share.

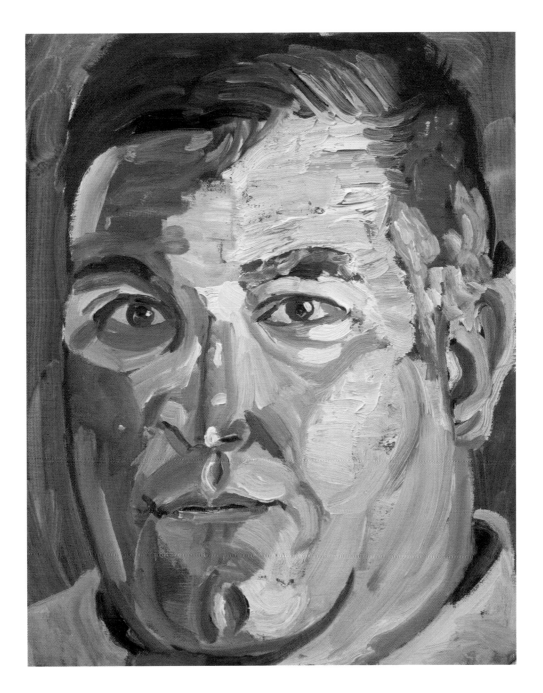

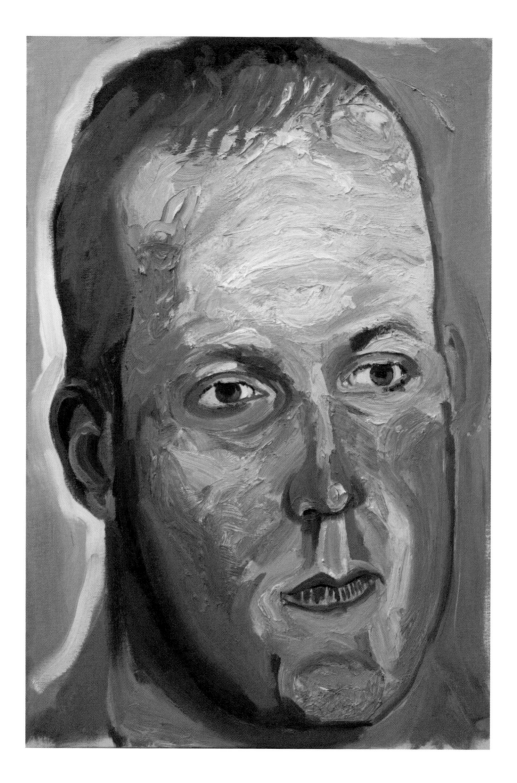

BEN DELLINGER

UNITED STATES ARMY, 2003-2009

Ben Dellinger brought his eight-year-old son, Ayden, as his guest to the 2013 Warrior Open. "Obviously I wanted him to meet the President," Ben says. He also wanted his son to see that there were others who had lost limbs in defense of our freedoms. "I thought it'd be good for him to meet other people like me and see that I'm not the only one, that there are thousands of us," Ben says. "I didn't want him to think I was the only one who gave something."

Ben signed up for the Army on a delayed-entry program and joined the ranks in 2003. "I was in college when 9/11 happened," he says. "It made me angry. Long story short, I felt I was obligated to do something about it."

Ben went to Baghdad in 2007 as a part of what became known as the Surge, the increase in troop levels I ordered that successfully quelled the violent insurgency in Iraq and helped bring order to the young democracy. After losing his leg in an IED blast, Ben had to learn how to walk again on a prosthesis.

At our golf tournament six years later, Ben nervously prepared to hit his tee shot in front of a large gallery. I must admit, I didn't do much to calm him down. "Hey, Dellinger," I needled, "lot of people watching. Don't mess up!" He didn't. He nailed the ball 285 yards, straight down the fairway. "I picked up my tee and looked towards President Bush for approval," Ben later wrote, remembering that morning. "He nodded with a little eyebrow raise, and I could see in his face that he may have been a little impressed."

Ben was right. I was impressed with the shot, as was Ayden. And I'm impressed with the man who hit it.

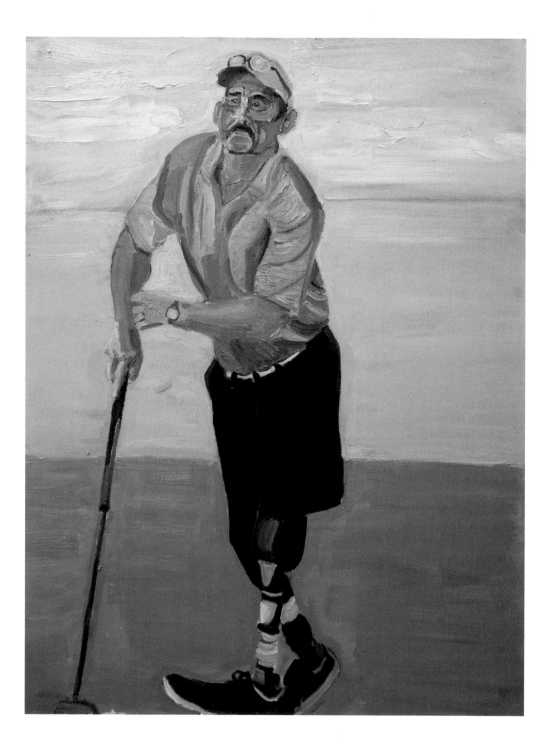

JACQUE KEESLAR

UNITED STATES ARMY, 1990–2011

Jacque "Jake" Keeslar joined the Army in 1990. "All I wanted to do was jump out of planes," he says. He found that Army life suited him. He was proud of his service—of "doing the right thing"—and decided early on that he wanted to complete a twenty-year military career.

So in 2006, when Jake "got blown up" in Iraq, as he put it, the first thing he told his commander was that his injuries wouldn't retire him. But the IED that Jake's Stryker vehicle had hit resulted in the amputation of both his legs, one above the knee and one below. "When I woke up, I realized I was shorter than I used to be," he says. Not the kind of man to sit around, Jake told his doctors, "Well, let's get the legs! Let's get up and go!"

"The therapy that I received at Walter Reed was top-notch," Jake says. He spent eighteen months there recovering and found golf to be an effective form of rehabilitation. The varying terrain of the course helped him learn how to walk on his new prosthetic legs. Swinging a club while keeping his balance helped him find his new equilibrium. Sand traps were a two-for-one bargain—the challenge of climbing in and out of them helped him hone his game to avoid them.

After his injury, Jake returned to active duty for another five years in a unit that helps wounded veterans transition to civilian life. "We helped the wounded guys coming home get the right treatment, get the right programs and everything they needed." His last assignment was as a platoon sergeant for a wounded warrior unit in San Diego, California Jake's home state. He and his wife, Vanessa, live in Temecula, where Jake recently graduated from Professional Golfers Career College. He retired after serving honorably in the United States Army for twenty-one years.

CHRIS DEMARS

MASSACHUSETTS ARMY NATIONAL GUARD, 1988–2015

For Chris Demars, who deployed to Afghanistan with the National Guard and was severely injured there by a suicide bomber, overcoming the physical wounds of war was just one obstacle to transitioning to life back home. "When you're in the Army, you know what you've got to do all the time," he says. "I had a whole company of soldiers to lead. That adjustment from being important and doing something to just taking care of yourself—that's hard, because you used to take care of everybody else."

Chris's PTS and TBI made it difficult for him to control his mood. His relationships became strained to the point where his wife, Terri, finally convinced him to seek help. Chris reached out to the VA and started cognitive therapy. "I found group therapy to be the best for me. I also learned from the Vietnam veterans in my group how *not* to deal with PTS. They all said they wished they went out for help earlier after returning from war."

Chris's physical recovery was no cakewalk. "I always felt like I was taking a step forward and then two back," he says. "What really inspired me," Chris recently wrote, "was watching the wounded warriors at President Bush's first W100K on Fox News. I looked at my mom and dad and said, 'I am going to do that next year.'" And he did.

Through the ride, Chris met Josh Hansen, another injured war fighter and mountain biker who started a military service organization called Continue Mission. "His work inspired me to do a ninety-three-mile, three-day mountain bike ride to raise money for veterans groups," Chris says. He donated half of the proceeds to a wounded warriors group in Boston and half to Continue Mission. Chris's mission continues today at his alma mater, Greenfield Community College, where he serves as veterans counselor. He does something he's skilled at and is proud of: helping veterans like him succeed in academic and civilian life.

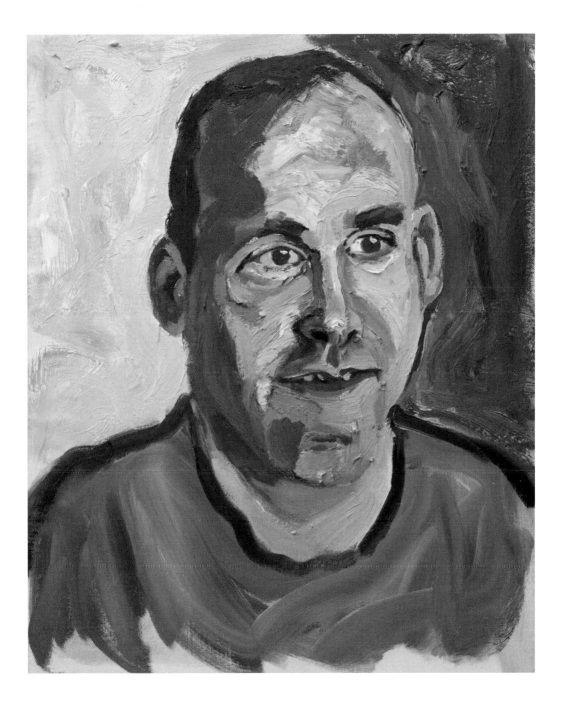

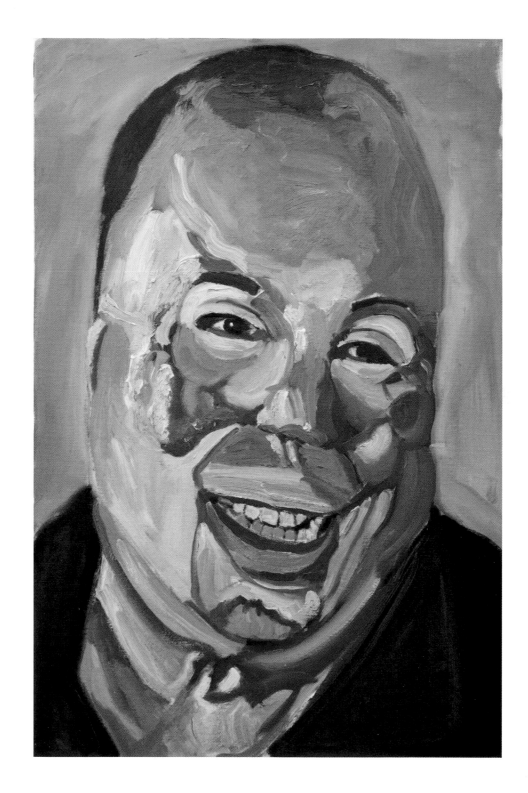

ISRAEL DEL TORO JR.

UNITED STATES AIR FORCE, 1997–PRESENT

———————————————

"I made a promise that I'd always be there for him.
I would not let my son grow up without his dad."

———————————————

ISRAEL DEL TORO JR. doesn't remember the first time we met. I'll never forget it.

When I visited Brooke Army Medical Center on New Year's Day 2006, "DT" was in a medically induced coma. His Humvee had been hit by a roadside bomb in Afghanistan the month before, severely burning 80 percent of his body. His fingers and nose were pretty much gone, and the military physicians had given him a 15 percent chance of surviving. I did what I could to comfort his sweet wife, Carmen. We prayed together and spent time talking to DT. I was confident he couldn't hear me. I was not confident I would ever see him again.

The doctors' prognosis overlooked a medical intangible: the courageous, selfless, determined character of this good man. They didn't know that DT had made a commitment to his young son. "I made a promise that I'd always be there for him," he says. "I would not let my son grow up without his dad." As they would soon discover, DT is a man of his word.

A few months later, DT woke up from his coma. When he looked in the mirror and saw the extent of his wounds, he was shocked. "I'm a thirty-year-old man," he later told ABC News. "If I think I'm a monster, what's my three-year-old son gonna think? I don't want my son to be scared of me."

On top of his new appearance, the doctors told him he would never walk or breathe again on his own. With Israel III in mind, DT decided to prove them wrong. He vowed then and there to recover and lead a constructive life.

After more than a hundred surgeries, and with support from Carmen and encouragement from Israel III, DT recovered. Then, he reenlisted—the first airman to do so with a disability rating of 100 percent. Today, he's still in the Air Force and was recently promoted to master sergeant. DT is a member of the Air Force's World Class Athlete Program and a nationally recognized motivational speaker. "I love my job," he says. "I love what I do."

I've seen DT several times since our first meeting in his hospital room, including at the 2016 Invictus Games, where he represented the United

States in cycling and powerlifting and earned the gold medal in shot put. DT embodies the spirit of the classic poem for which those games are named: "I am the master of my fate. I am the captain of my soul." Onstage at the opening ceremonies, Israel described his mantra a little less poetically: "Never quit. Never ★★★★ing quit!"

I'm no poet, either, so instead I've tried to capture DT's contagious, hopeful, joyous energy on canvas. I hope those who see it get a sense of DT's unconquerable soul and take inspiration from my friend's powerful example.

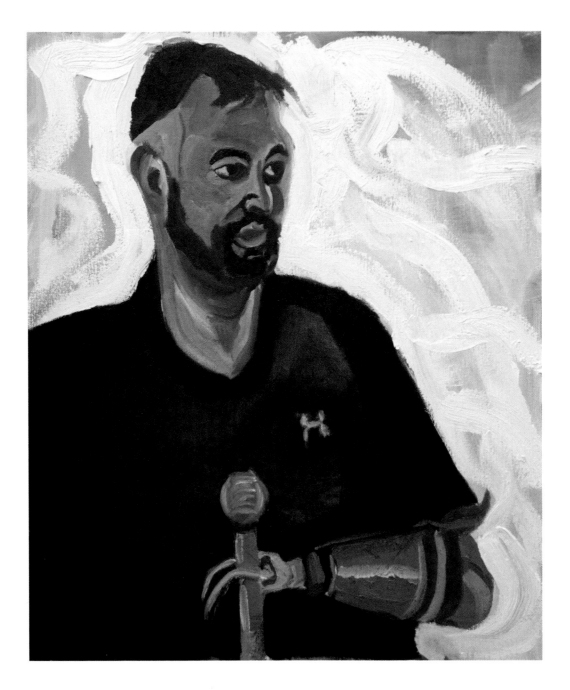

STAFF SERGEANT
MATTHEW DEWITT

UNITED STATES ARMY, 1998–2004

In 2003, Staff Sergeant Matt DeWitt and his teammates were among the first to arrive in Baghdad. His unit with the 19th Cavalry stormed Saddam's palaces and reclaimed them for the Iraqi people.

Later in his tour, Matt fought in Fallujah. During a raid on an enemy holdout, he was manning his Humvee's turret when an RPG struck the front of his truck. Matt was shaken but okay. Then a second RPG made a direct hit on his gun. "It pretty much knocked me down from there," he says. "That's what caused all my injuries." Matt was medically evacuated to a hospital in Germany and then on to Walter Reed. He lost both of his arms just below the elbow and suffered serious leg injuries.

"It took me about a month before I was walking again," Matt says. When he left the hospital—and the military, where he had served since 1998—he felt lost in the world. "I pretty much went off the grid for a year," he says. He went back to school for his degree and tried to take up his old hobby, mountain biking. "It didn't turn out so well the first time, so I put it on the back burner."

Matt's health faltered as he struggled to find his new place in life. That's when he received a visit from a concerned childhood friend, who took him to a NASCAR race. Matt doesn't know what clicked exactly, but he says that somehow he realized he had to get on with his life. "That's when I got hooked up with Ride 2 Recovery. From there, I just started putting on the miles and completing a lot of their challenges, and it's been great." His goal is to complete the Leadville Trail 100, a grueling hundred-mile altitude race famous for its difficulty. He trains when he can find the time between raising his three boys with his wife, Catrina, and starting their new farm.

In this portrait, I painted Matt's claw to show the wonders of modern prosthetics. More important, it is a sign of Matt's determination to live a full life.

KEVIN L. ROSENBLUM

UNITED STATES ARMY, 2004–2009

The five a.m. flight from Richmond, Virginia, to Dallas was pretty quiet until the American Airlines captain came over the loudspeaker with an announcement about another captain on board. "Ladies and gentlemen, we're honored to have a special guest with us this morning. Army Captain Kevin Rosenblum, who was wounded in Iraq in 2005, is on his way to participate in a 100-kilometer mountain bike ride with President George W. Bush." The cabin burst into cheers and applause.

Kevin had deployed twice to Iraq. "One month into my first deployment, we were ambushed with mortar and small arms fire. Nine of us were wounded in the attack, but thankfully we all survived," Kevin says. He took shrapnel in his right leg and left arm, but he managed to recover, complete his deployment, and serve another tour in combat.

After completing his service, post-traumatic stress symptoms started to surface. "When you get out of the military, sometimes you lose momentum," he says. "The military is kind of one big family. Having lost that support structure, I just kind of went inside—inside my own head, and physically inside."

Kevin found the missing support structure through a veterans service organization called Team Red, White & Blue—and from a pretty girl named Genia, to whom he is now married. He got back outside through endurance sports like trail running, mountain biking, and triathlons. "Now I have a healthy and productive outlet for my PTS, and the confidence and tools to bring me out of my own head," he says.

When Kevin was announced on his flight to Texas, the passenger next to him thanked him for his service. More important, he asked Kevin about his career in the Army and his transition. As it turned out, Kevin's seatmate was an entrepreneur in search of an operations manager for his growing business. Weeks later, Kevin joined the company. Today, he remains closely involved with Team Red, White & Blue and plans to continue serving his community and fellow veterans for the rest of his life.

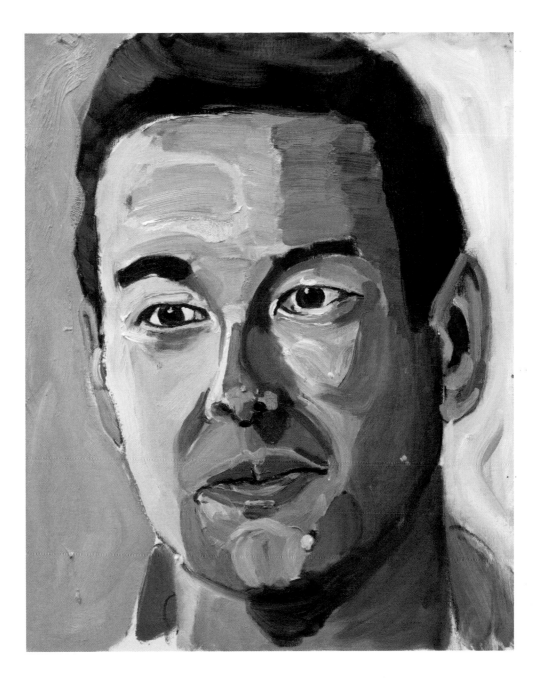

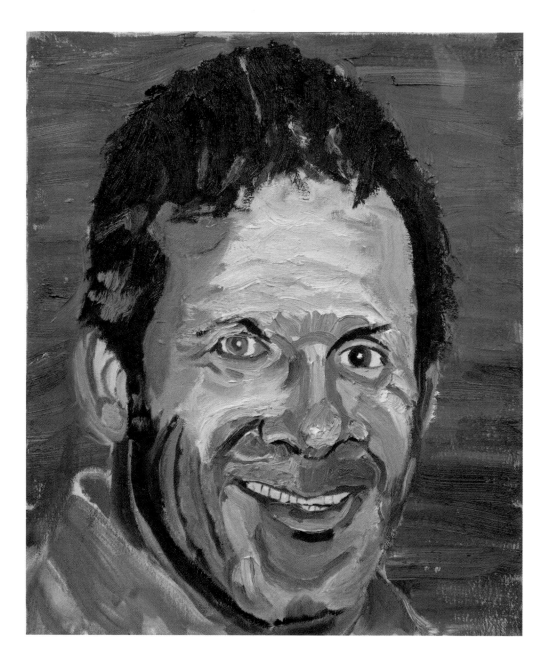

BRIAN DONARSKI

UNITED STATES MARINE CORPS, 1987-1998

UNITED STATES ARMY, 2004-2012

Brian Donarski—also known as Ski—served a decade with the Marines before being medically discharged for a shoulder injury. After 9/11, he decided to waive his VA benefits and spent three years battling for medical clearance to reenlist in the Army. He went to Iraq in 2005, where his deployment was cut short when a roadside bomb shattered his neck and back, leaving him with a traumatic brain injury, some vision loss, and PTS.

When Ski woke up at Walter Reed, a nurse was holding his hand. In her other hand were the letters from his two daughters that he'd carried with him during his deployment. Support from McKenzi and Maya gave Ski the motivation to recover.

Ski returned to active duty and went to Afghanistan. His colonel even recommended him for Officer Candidate School. It was a remarkable recovery, but not without setbacks. At military intelligence school in 2010, Ski was hit by a pickup truck, triggering his invisible injuries in serious ways. "I couldn't relate to society," he says. "I couldn't keep up. I would fall to my knees, because I couldn't process things." He struggled to focus and manage his emotions.

Fortunately, the Salute Military Golf Association introduced him to the game that helped get his life back on track. He competed in the Warrior Open in Dallas, but on the last day of the event, Ski received devastating news. "Angel Rivera Jr., my best friend from the 7th Special Forces who saved my life, tragically took his own life." Ski knew immediately that he needed to get to North Carolina to be with Angel's wife and children. I instructed my staff to get him there right away.

Ski told me later that Angel's family is doing better, "coping with this horrible, tragic loss." So is Ski. He's a remarkable golfer. And as a national community ambassador for Challenge America, he uses his big heart to help military families deal with the struggles he has overcome.

KENNETH MICHAEL DWYER

UNITED STATES ARMY, 1998–PRESENT

———————————————

"I have the greatest job in the world."

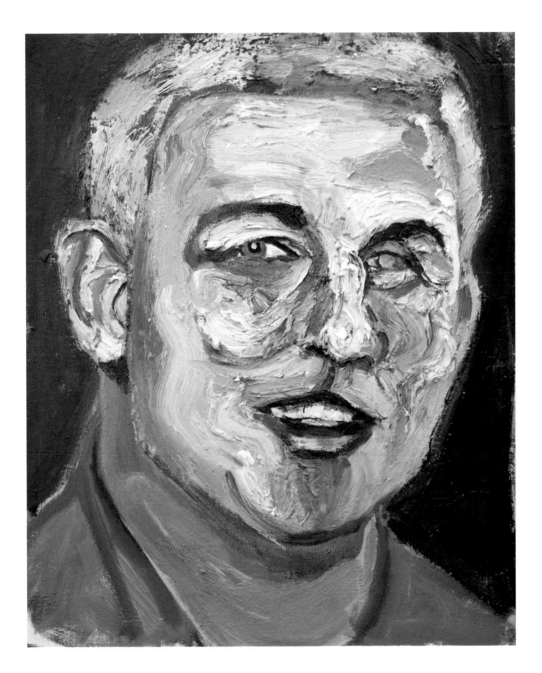

KEN DWYER is perfectly at ease talking about his injuries. I know firsthand. When I introduced Ken to my friend, golf legend Lee Trevino, I could tell that Ken had the rare sense of humor to match Lee's. Lee told a few jokes. Then when Lee asked about the unusual glimmer in Ken's left eye, Ken launched into a story.

"I was at one of my son's baseball games not too long ago," Ken told us. "The umpire made a terrible call, so I marched onto the field and right up to the ump." At this point, Ken reached up and pulled his prosthetic eye right out of its socket.

"Good Gawd Almighty!" Lee screamed.

Ken went on as if nothing unusual had happened. "I removed my eye, put it in my hand, and thrust it towards the ump," he recounted. "I told him, 'Here, you seem to need this a lot more than I do.'" Ken said the umpire didn't find the gesture all that funny, but Lee and I sure did. And to answer Lee's question about Ken's eye, he showed us that emblazoned right there on the eye is the Special Forces regimental crest. Ken pointed out the scroll along the bottom, which reads, *DE OPPRESSO LIBER.* *"To Free the Oppressed,"* he said, reciting the Special Forces motto, "words that ring very true in light of our current conflicts and the tens of thousands who suffer under oppressive regimes."

Ken was a military man from birth. He was born at MacDill Air Force Base. His father and both of his grandfathers served twenty years each. In 1998, after graduating from Furman University, Ken joined the Army.

In August 2006, during his third deployment to Afghanistan, Ken was on patrol when an RPG hit him, severing his left arm immediately and splitting his right. Shrapnel took out his left eye, broke his trachea, and damaged his esophagus. "People tell me that I'm making this story up, but it's the God's honest truth," Ken says. "As I'm lying there on my back, looking up at the bones poking out of my wrist, the very first thought that went through my brain was, 'Damn, that's going to suck for my golf game.'"

For his first five weeks at Walter Reed, Ken wasn't allowed to see his three-year-old son because of the severity of his injuries. But everything changed for Ken when the staff finally brought Timothy in. "He leaned

over to my right arm, which had just been stitched closed, and gave me a kiss right on the center of the stitch," Ken remembers. "Without one tear and with complete conviction in his voice, he proclaimed, 'It's all better now, Daddy. Let's play baseball.' At that second the only thing that mattered was figuring out a way to heal, a way to fight through the adversity, and a way to play baseball with my son."

Learning to play baseball with one arm was easier said than done. But Ken is resourceful, and he happens to be a knowledgeable baseball fan, so he started watching old videos of Jim Abbott, the one-armed major league pitcher who threw a no-hitter for the New York Yankees in 1993. He noticed that Abbott had a special hole in his glove that enabled him to slide it on and off quickly after each pitch, so Ken cut a hole in his. Then he practiced—a lot. Before long, not only did Ken get back to playing baseball, he also got back to active duty and kept his Airborne status. Ken served another tour in Afghanistan after his injuries and is now a lieutenant colonel and the executive officer of the Special Warfare Training Group at Fort Bragg. "I have the greatest job in the world," he says. "I get to go to work every day with guys who are willing to sacrifice their lives for me, and I'm willing to do the same for them. I don't think you can find that anywhere else."

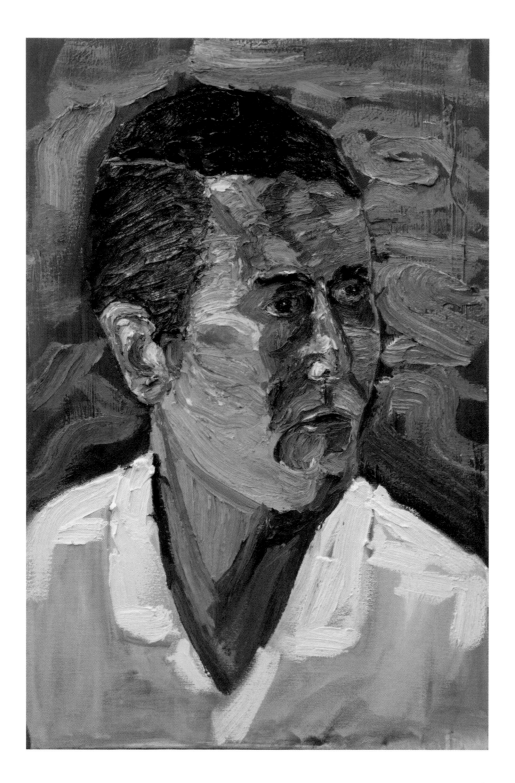

SERGEANT
JAY K. FAIN JR.

UNITED STATES ARMY, 2005–2008

On June 26, 2007, Jay Fain was wrapping up an eleven-month tour in Iraq and preparing to head home to Columbia, South Carolina, the next day. He hitched a ride in a Humvee to the airfield at Camp Taji, but never got there. His vehicle hit a roadside bomb. Jay was burned from the blast, and shrapnel pierced Jay's intestines and severed the femoral artery in his right leg.

Jay woke up in a hospital in Iraq. His right leg was amputated all the way up to the hip. His dad, a thirty-six-year Army man who was also stationed in Iraq, was by his side.

Jay recovered at Brooke Army Medical Center's Center for the Intrepid in San Antonio. His mom helped him along the way. "She's a huge golfer," he says. "She's club champion at Fort Jackson Golf Club where we live in Columbia." One day, Jay decided to go with her to the driving range. "I had enough strength to balance on one leg, so I just threw the crutches aside." He started to learn how to swing again. To get better, he knew he'd need another leg.

"My prosthetic clinician, John Ferguson, fitted me with my first prosthetic leg. We went into the parallel bars and I did so well, he said I was going to be fine." It was a turning point, Jay says. "Because of his passion at that moment, I felt confident that I would walk again."

Jay did walk. And now he runs, rides his Harley, cooks, and lifts weights. Fitness, friends, family, and counseling helped Jay build a new life. Today, he works for a prosthetics company, where he's grateful for the opportunity to help others in the same way John Ferguson, his prosthetic clinician, helped him.

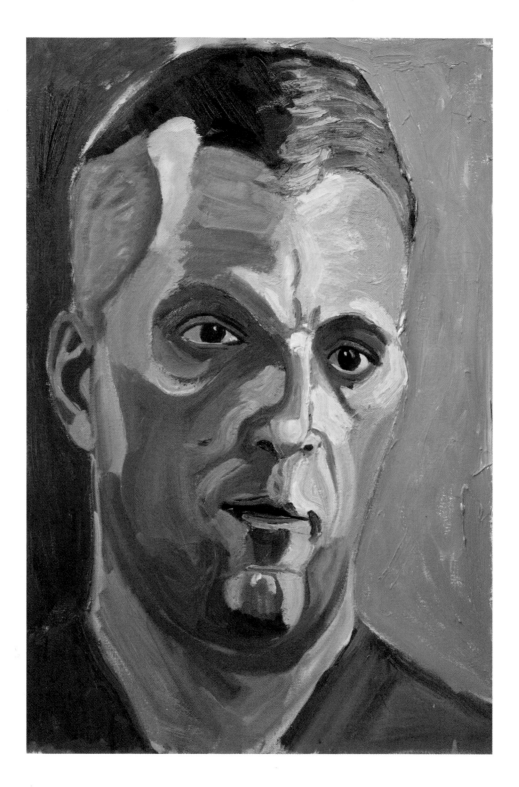

LIEUTENANT COLONEL
DANIEL GADE

UNITED STATES ARMY, 1992–PRESENT

"Don't let people tell you that
you're 'broken.'"

In late 2004, **DAN GADE** was hit by an RPG in Iraq. Dan was a West Point graduate and a company commander responsible for leading a 150-soldier tank company, and he was determined to stay with his team. So he recovered and continued his deployment. "We were very much a direct ground combat unit, and I was in charge of it," he says matter-of-factly. "We did raids, ambushes, patrols, and security operations. I didn't ever ask them to do things that I wouldn't do."

Just two months after reentering combat, Dan was seriously wounded by an IED. He returned from Iraq unconscious and spent the first third of 2005 in the hospital. He had a skull fracture and a broken neck and back, and he lost his entire right leg at the hip. He has undergone more than forty surgeries in the years since.

So watching Dan ride a mountain bike in the Palo Duro Canyon near Amarillo, Texas, in 2012 was unbelievable. Dan rode with one leg, navigating some really tough trails. Even after falling on some of the more treacherous turns, he would get right back up and say with a grin, "Let's go!" On the steepest hills, we'd hop off our bikes and provide Dan with a little extra torque, in what became known as the "Bush Push."

Dan told me he credits his recovery to his wife, their girls, and his desire to serve God. "Those are my prime directives; the rest is all gravy." To his fellow veterans, he urges, "Don't let people tell you that you're 'broken' or 'sick' or 'disabled' because of what happened. Don't let well-meaning organizations pay you to be sick. Get out there, get after it, and make a meaningful life."

I once heard this message in a unique way. At our W100K events, we ask the riders to stand up and tell the audience about their lives. When Dan Gade's turn came, he told a story of his little girl, who asked her dad to play Legos with her not long after his injury. Dan said he couldn't play with her; he was too hurt. Then he heard his little girl say to herself, "My daddy can't do anything." Gade paused and gathered his composure in front of the crowd of vets and strangers. In a strong voice, he declared, "That is when I decided I would do everything, especially for her—including riding mountain bikes with you, Mr. President."

So he did. By the time Dan retires from the Army, he will have finished serving twenty years of active duty, more than half of which will have been since his injuries. He started his master's degree a year to the day after his injury and has since earned a PhD from the University of Georgia. He competed in Ironman and Race Across America events. He worked at the White House on veterans' issues during my administration and was appointed to the National Council on Disability by the Speaker of the House. For the last five years, he has taught public policy to cadets at West Point in the social sciences department, and he writes extensively on veterans policy. And, of course, he spends a lot of time playing with his daughters.

In May 2013, my staff informed me that Dan was being promoted from major to lieutenant colonel. In a break with protocol, I invited him to my office so I could administer the ceremony myself. As I pinned Dan's new insignia on his uniform and saluted him, I was overcome with an incredible sense of pride and gratitude for Dan's service to our country, both on and off the battlefield.

TIMOTHY GAESTEL

Tim Gaestel was scheduled to leave for basic training on September 11, 2001. That morning, our country—and Tim's future—changed forever.

Tim served two combat tours with the 82nd Airborne, one in Afghanistan and one in Iraq. Just ten days after he arrived in Iraq in September 2003, Tim's Humvee was hit by two roadside bombs on an infamous stretch of road known as Ambush Alley. His legs and back were severely wounded by the shrapnel. Tim recovered in Iraq and completed his deployment, despite the persistent pain of his injuries.

When Tim's unit returned stateside, they resumed their physical training regimen with a six-mile run. Tim managed to finish the run. Then, he collapsed. "I couldn't feel my legs, and my back was on fire," Tim says. "I knew then that I couldn't be the kind of soldier that I wanted to be, so I needed to go do something else for my community."

Unfortunately, that "something else" didn't reveal itself right away. "It was hard seeing how the country was just moving on," Tim says. "I came back to Austin and saw a concert with friends. People were happy and dancing around like nothing had happened. There was a war going on, and they didn't seem to know it."

Tim secluded himself, having lost the desire to hang out with his friends. He started dropping classes at Texas State University. He stopped exercising because of the pain and gained weight.

He felt alone, but he wasn't. "I want to thank my father," Tim says. "He saw me struggle and saw that something was wrong. One day he pulled up and demanded I come out and play golf with him." Something just clicked out on the course. "It got me back on my feet, back moving, back doing something. I became hooked. Golf saved my life."

He's good at it, too. He recorded a hole-in-one at our tournament. Today, Tim teaches history and coaches golf at Vista Ridge High School, in the district from which he graduated.

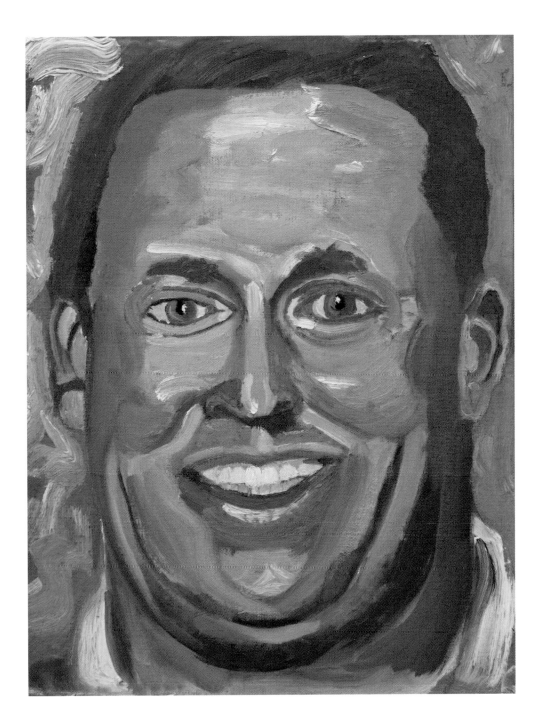

STAFF SERGEANT
ROBERT DOVE

UNITED STATES ARMY, 2008–2014

"I have re-learned to do what
I love, and that helps to keep
me busy and happy."

SERGEANT FIRST CLASS
JOHN FAULKENBERRY

UNITED STATES ARMY, 2001–2012

"I remember hearing on the radio,
'We need to get out of here or
Faulkenberry is going to die.'"

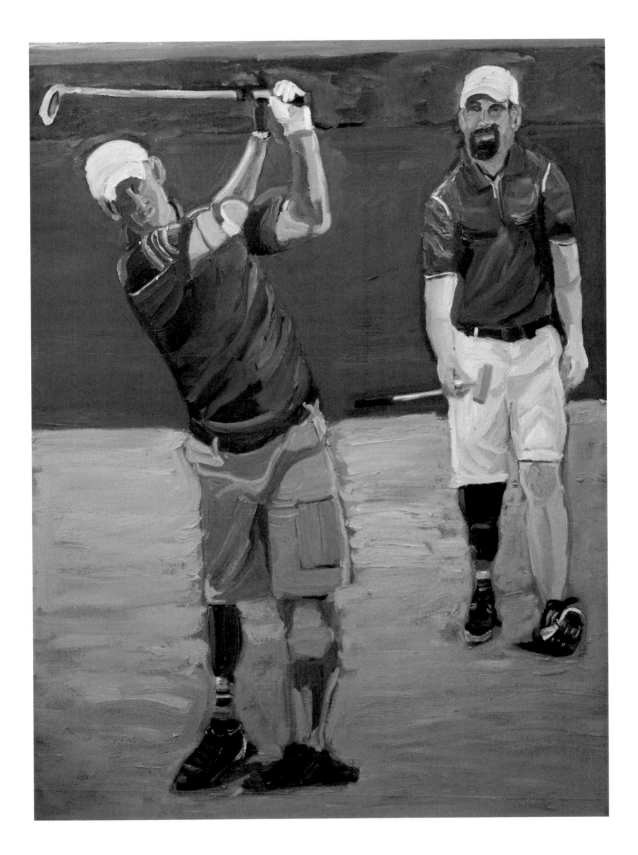

As **BOBBY DOVE** tells it, his father and grandfather had an outsize influence on the path his life would take. His dad, an avid outdoorsman, took Bobby hunting and fishing every chance he got—and when Bobby wasn't outside, he was with his grandfather, watching military programs on the History channel and asking about his grandfather's experience in the Korean War. When it came time for Bobby to launch his own career, he made choices that honored both men. He started out working for Colorado Parks and Wildlife. Then in 2008, he followed in his grandfather's steps, joining the United States Army and deploying to Afghanistan as a Special Forces medical sergeant with the Green Berets.

In 2012, Staff Sergeant Dove was on a combat reconnaissance patrol north of Kandahar when his dirt bike hit an IED. The explosion knocked Bobby out, blowing off his right hand and right leg and breaking his pelvis. When he came to, Bobby was the only medic on the scene.

His medical training kicked in. He tried, with his left hand, to treat himself—but the same medical training told him he probably wouldn't make it. His teammate Cliff Beard rushed to his side. Bobby told Cliff exactly how to stabilize him, starting with the order *"Tourniquet, tourniquet, tourniquet!"* Cliff followed Bobby's every instruction. And it worked. Cliff saved his life.

During Bobby's six-month recovery at Walter Reed, he thought about the things he loved: the outdoors, the military, and his future wife, Emmy. (Bobby asked her father for her hand in marriage when he woke up in the ICU.)

Today, Bobby and Emmy love teaching their young son about the great outdoors. And Bobby runs Hooligan Charters, a fishing guide business out of Destin, Florida.

JOHN FAULKENBERRY was born and raised in my hometown of Midland, Texas. He signed up to join the Army while still enrolled in high school. Even at that young age, John says, "I was one hundred percent sure that's what I wanted to do."

John served three deployments: two to Iraq and a third to Afghanistan in 2007. That July, in the Korengal Valley, John's unit came under fire from both sides of a river. They took heavy casualties in the ambush. John was targeted while trying to recover the body of his company commander. "I was shot by a PKM [machine gun] multiple times in the right upper thigh," he recounts, "basically cutting my leg in half. The bullets blew out my hamstring and quad, severed my sciatic nerve, blew out three inches of my femur, and lacerated my femoral artery. I remember hearing on the radio, 'We need to get out of here or Faulkenberry is going to die.'"

For the next three years, John fought to keep his leg. Eventually, with support from his wife, Sarah, and doctors, he made the excruciating decision to amputate. Looking back on it, John considers it the best decision of his life. It freed him to begin his recovery in full and start running, climbing, and playing golf again.

But John's biggest challenge wasn't adjusting to his new leg—it was getting acclimated to civilian life. "The hardest part of the recovery is the actual transition out of the military," he says. "As many people in my situation do, I turned to alcohol to combat physical pain and memories." It was then that John made another courageous decision: to seek cognitive therapy. "The end result," he says, "is a good family man that is happy, healthy, and hopeful for the future for the first time since I was wounded." John shares that hope with other veterans through his work as a director with the Military Warriors Support Foundation.

ALEXANDER GLENN-CAMDEN

The bullet lodged between Alexander Glenn-Camden's vertebrae will remain in his neck for the rest of his life. Alexander was on a dismounted patrol in 2011 when his platoon was ambushed in Afghanistan. Both Alexander and a fellow soldier were shot in the neck. Miraculously, both survived.

"I was home rather fast and unexpected, which made it all very confusing in the beginning," Alexander says. The transition from military to civilian life is challenging, even more so when the transition period is so short. When his doctors told him the bullet couldn't be removed, Alexander struggled to accept his new reality. He also struggled with PTS and depression. Open areas made him nervous, and he got jumpy when people approached from behind. "I often just sat in my room with no real drive to get out and get my mind off of getting hurt and the deployment."

One day, he decided he was through with idle time. "I saw the golf clubs sitting in the closet and decided to go to the range." No one accused Alexander of being a natural on his first day. "I quickly realized I sucked," he admits. But Alexander was undeterred. He went home, watched YouTube videos, and started to perfect his swing. "The next thing I knew, I was hooked!" he says. "I found myself obsessing over all things golf rather than my injury or the PTS I was dealing with. It gave me something to do other than sitting around being depressed and feeling sorry for myself."

By stepping out of his comfort zone and onto the golf course, Alexander realized the wealth of possibilities before him. He later spent time shadowing firefighters at Los Angeles Fire Station 15 and found his new purpose in life. "Right now I'm in the process of obtaining my fire technology degree," he shares. "When I'm not in class, I'm on the course perfecting my game or relaxing with family. I guess you could say I'm living the dream."

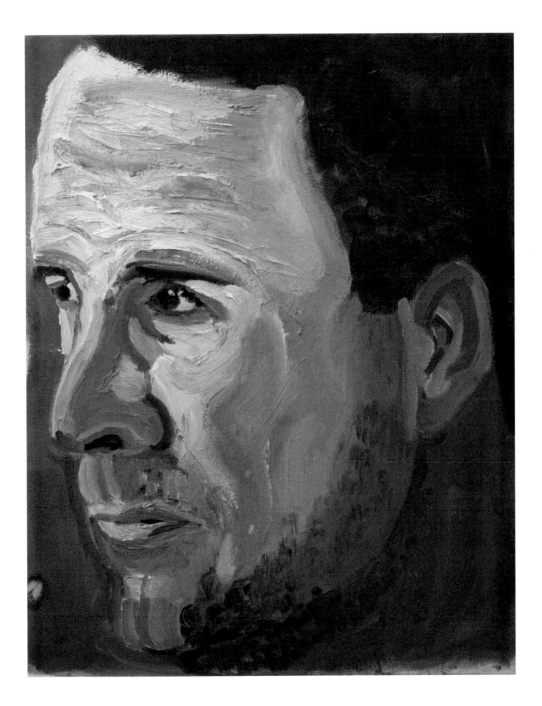

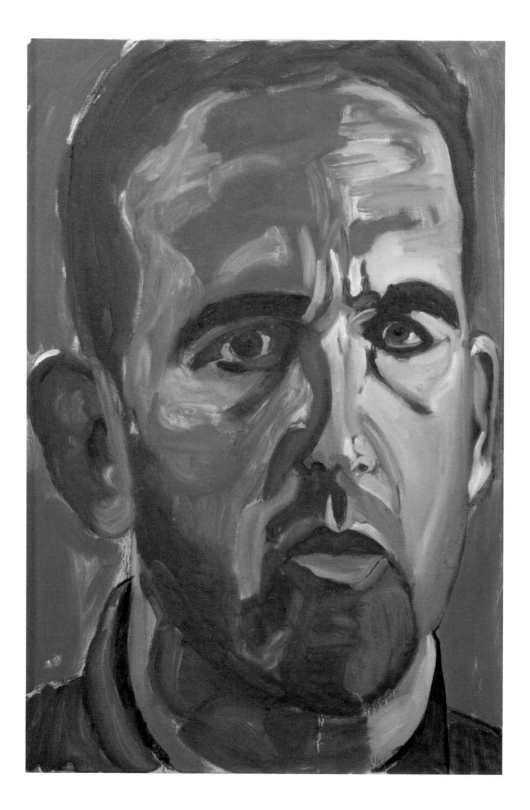

CHRIS GOEHNER

UNITED STATES NAVY, 2003–2006

For five years after returning from Iraq, Chris Goehner couldn't sleep at night. In 2005, during his second deployment to Iraq as a Navy corpsman, he saw more than 1,200 trauma patients and assisted with some 450 operations. "Nighttime is when we always got attacked. Nighttime is when a lot of our trauma cases came in. Nighttime on my twenty-first birthday is when we were attacked by mortars," Chris recounts. "If you slept, that's usually when bad things happened."

Seeing that many trauma patients took a toll on Chris. He was diagnosed with PTS and medically discharged in 2006. Insomnia and nightmares haunted him. He also struggled with survivor's guilt, which overcame him while visiting the grave of Staff Sergeant Doug Richardson, who died under his care.

Chris later connected with Doug's brother Paul, a Marine. "He gave me the chance to say sorry and release the guilt. Now Paul and I are able to talk when times are tough and we're thinking about Doug." Little by little, Chris started to recover. He got down from twelve medications to zero. He realized alcohol didn't numb the memories but exacerbated them. He started to participate in marathons and triathlons as therapy.

Another part of Chris's recovery has come through thinking about his experiences and contributions from a positive perspective. Chris originally joined the military because no one from his family had served in combat. "I didn't feel that my family should be able to reap the benefit of national defense without having made some sacrifice. It was my time to make the sacrifice," he says. Chris is rightly proud of that sacrifice, particularly of how many Iraqis his team helped to treat and heal. "Nobody can dispute that our mission and how we helped during the war was purposeful and for the greater good."

Chris's service to mankind continues today in South Africa, where he works to give children in vulnerable populations meals, tutoring, and Bible education.

LIEUTENANT COLONEL
DAVID HAINES

UNITED STATES ARMY, 1983–1986 AND 1992–2012

ARMY NATIONAL GUARD, 1986–1991

David Haines joined the Army right after he graduated from high school. "To be honest," he says, "the primary motivator at the time was to get money for college." David served three years and used his benefits to earn a degree while remaining in the National Guard. "As I was going through college, though, I realized the Army was the best match for what I wanted to do with my life. So I came back and made a career of it."

David rose through the ranks in his decades-long career. While deployed to Iraq in 2006, his vehicle was hit by an explosively formed projectile. "It instantly killed my counterpart, Major David Taylor," David says, "and the three other people in the vehicle with me all lost limbs." David's left arm and entire right side were shredded by shrapnel. He spent months in the hospital and almost three years in rehabilitation.

A significant turning point came when a military doctor in Germany asked David to describe his recovery goals. He blurted out, "Stay in the Army and be able to ride my bike and motorcycle again." By simply saying out loud what he wanted to do, he was able to visualize his recovery and muster the will to achieve it. Motivation also came from the family of his fallen comrade, Major David Taylor. "In spite of their loss, they had the strength to care for me and the three other soldiers who were injured when Dave was killed."

David stayed in the Army for another six years, honoring his friend's sacrifice and completing his career as commander of a battalion in charge of caring for wounded soldiers at Fort Knox. David retired from active duty in 2012 but continues to work for the Department of the Army as a civilian. As he reminds his fellow soldiers, "Our responsibilities to this great country do not end when we leave service. We know best the cost of defending our country and Constitution. We are the best hope of preserving it."

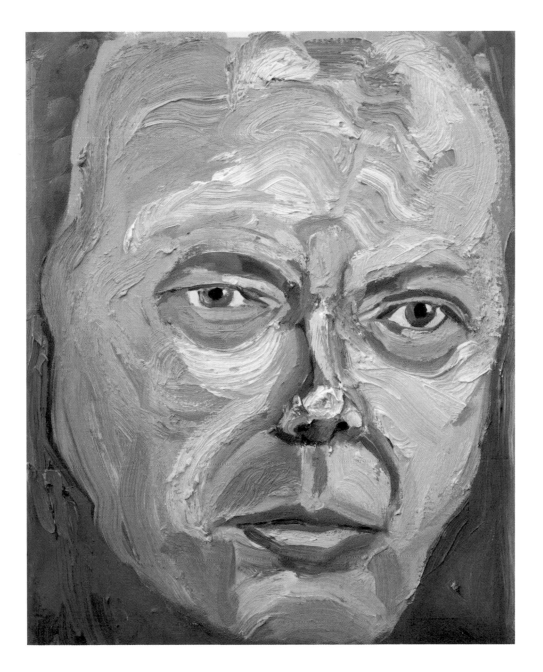

MURAL OF AMERICA'S ARMED FORCES

PANEL 1

CLOCKWISE FROM TOP LEFT

CORPORAL ERIC ELROD

SERGEANT MICHAEL STAFFORD

FIRST LIEUTENANT MELISSA STOCKWELL

LIEUTENANT COLONEL JUSTIN CONSTANTINE

TECHNICAL SERGEANT DAVID ROMANOWSKY

STAFF SERGEANT JOSHUA CHINN

STAFF SERGEANT JOHNNIE YELLOCK (*CENTER*)

PANEL 2

CLOCKWISE FROM TOP LEFT

CHIEF WARRANT OFFICER TWO SAM MORTIMER

FIRST SERGEANT ROBERT FERRARA

SERGEANT JOSH HANSEN

SPECIALIST MARCO VASQUEZ

COMMAND SERGEANT MAJOR BRIAN FLOM

CHIEF WARRANT OFFICER FIVE JIM HERRING

MASTER SERGEANT CHRISTIAN COTE

FIRST SERGEANT PETER LARA

CORPORAL JOHN REGO

SERGEANT JUAN L. VELAZQUEZ (*CENTER*)

PROFILES CAN BE FOUND ON PAGE 181.

PANEL 3

CLOCKWISE FROM TOP LEFT

LANCE CORPORAL ADAM MCCANN

CORPORAL CHAD PFEIFER

MAJOR CHRISTOPHER CORDOVA

MAJOR JOHN D. GREER

SERGEANT FIRST CLASS MANNY COLÓN

STAFF SERGEANT JOSHUA KRUEGER

STAFF SERGEANT MIKE MORABITO

STAFF SERGEANT CHRISTOPHER MCCOY

SERGEANT DEWITT OSBORNE

STAFF SERGEANT ANDREW BACHELDER

SERGEANT LESLIE ZIMMERMAN (*CENTER*)

PANEL 4

CLOCKWISE FROM TOP LEFT

SENIOR CHIEF PETTY OFFICER STEVEN WININGHAM II

CAPTAIN MATT ANDERSON

STAFF SERGEANT JASON ROBERTS

FIRST SERGEANT JASON STAMER

STAFF SERGEANT ANDREW MONTGOMERY

STAFF SERGEANT NICHOLAS BRADLEY

COMMAND SERGEANT MAJOR WILLIAM PAUL (*CENTER*)

PROFILES CAN BE FOUND ON PAGE 181.

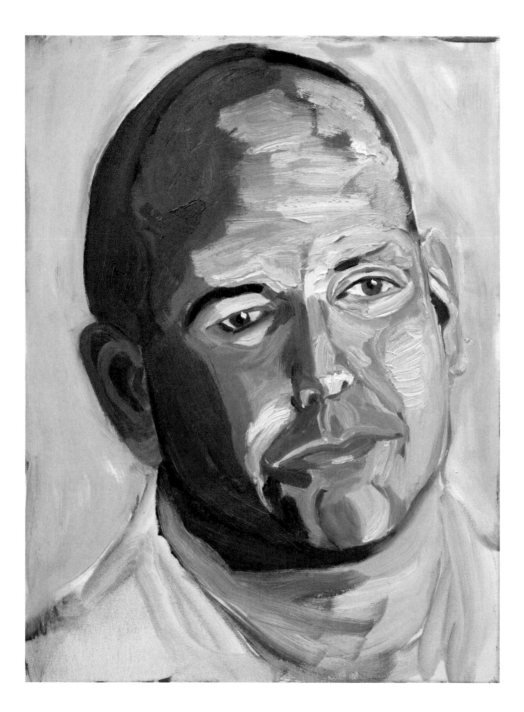

MICHAEL JOSEPH LEONARD POLITOWICZ

Michael Politowicz's grandfather was a Marine during World War II. "He's an Iwo Jima survivor," Michael shares. "If he could survive four amphibious landings, I figured it was my duty to follow in his footsteps." Determined to become a United States Marine, Michael joined right after high school. After an anaphylactic shock incident during boot camp, he was pulled from training. Disappointed but undeterred, Michael spent the next ten years fighting to qualify for the Corps. In February 2010, he finally earned the right to wear the Eagle, Globe, and Anchor.

Just months after completing boot camp, Corporal Politowicz stepped on an IED in Afghanistan. His forearm was reconstructed over three surgeries, and he continues to undergo physical therapy as well as psychiatric therapy for TBI and PTS. "My recovery was up and down. When I first got back, I was really—" Michael hesitates. "I was a shut-in. I had a hard time being around large groups, interacting with new people. I couldn't walk from my house to my car, and the migraines were excruciating."

A breakthrough came when Michael started seeing a psychiatrist and got help from two nonprofit organizations. Hope for the Warriors helped him with his mental needs, while Semper Fidelis Health and Wellness helped him become physically active again. They told Michael that their research suggested he would benefit from cycling. "I'm not riding a road bike," he said. "Are you kidding me? I'd look like a circus bear." They compromised and went with a mountain bike—a good move. "I rode the wheels off of it," he says. "Literally." His father-in-law, a fellow biker, sent replacements.

At one point after Michael's injury, he was asked what he wanted to do after he was medically retired. For the sake of propriety, it's probably best that a transcript of that conversation does not exist. Suffice it to say, Michael did not accept medical retirement. He returned to active duty in the Marine Corps, *Semper Fidelis*—always faithful—to his grandfather's legacy.

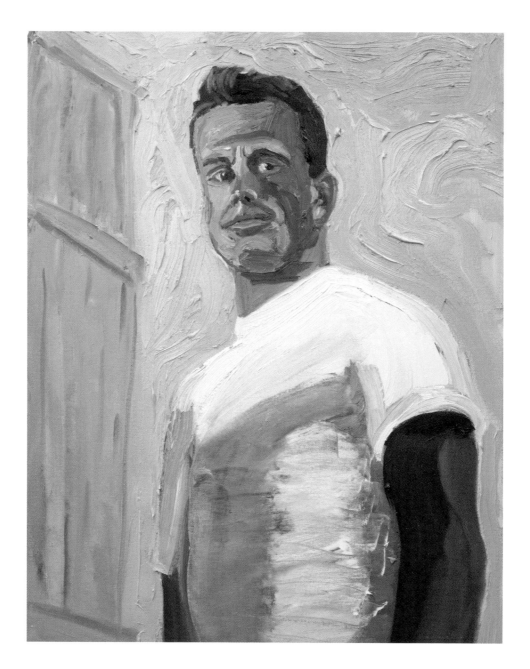

CORPORAL
DAVID SMITH

UNITED STATES MARINE CORPS, 2003–2007

"I look up to so many folks who had been

in the same hard place I was."

When **DAVE SMITH** finished telling the crowded room in Amarillo his story, I went over and gave him a big hug. I wanted him to know how proud I was of his courage to speak up. Dave had just shared with his mother and a crowd of perfect strangers that only a month earlier, he was staring down the barrel of a shotgun, ready to take his own life.

As a Marine Corps infantryman in Iraq, Dave says his job was "to take the fight to the enemy wherever we could find them." He recalls, "We did a lot of fighting, and we were all aggressive and numb—that's how we were supposed to be."

One night in 2004, Dave's unit came under heavy fire. Dave, trapped on the roof of a burning building, saw a muzzle flash from the alley below and identified a group of targets moving toward his position. In the fog of war, he acted on instinct and fired. "I made a failure of identification, severely wounding a fellow Marine who was a close friend," he says somberly. "It was the single most regrettable event of my life." The Marine Dave shot was sent home. Part of his foot was amputated, and he recovered. Dave was forgiven—his unit understood it was a mistake—but he felt ashamed for years, distant from his teammates. "I second-guessed myself every time I had to raise my weapon. I would rather have been killed than make a mistake like that again."

Dave was honorably discharged in 2007. He enrolled at UC Berkeley, where severe depression and post-traumatic stress ate away at his emotional state. "I enjoyed college but felt isolated, angry, and unable to connect with people who had never been to war. I didn't know what I wanted to do, and I missed being around people who understood honor, courage, and sacrifice. It was hard, and nothing seemed to make any sense. In just a few years I had gone from the happy, fun-loving kid I was in high school, Dr. Jekyll, to Mr. Hyde. At some point I just shut down as a person because I didn't know how to process or deal with it. I turned to alcohol as a solution. One night, that led me to decide to see if I really did care by putting a shotgun in my mouth."

Thankfully, Dave decided that he cared. He didn't pull the trigger. And when he woke up the next morning to a phone full of concerned text messages and voicemails, he realized that others cared, too. "I was

reminded that life isn't just a game I could end because I didn't like the way it was going for me," he says.

Dave sought professional counseling and got prescription medication for his anxiety, depression, and nightmares. Having confronted his trauma and learned to understand and accept it, he began building a new life. He refocused on his education, scoring straight A's in every semester after he put the shotgun away. Mountain biking kept him in shape and required him to think about the trails ahead of him, not the problems behind him. Travel helped Dave "get outside of my own head," as he puts it, and change the way he views the world and interacts with people. (He's up to fifty countries visited.) He found purpose by working as a volunteer, particularly with Team Rubicon, an organization that deploys veterans to provide relief in the wake of disasters around the world.

Dave says his motivation came from three sources. "First, I relied heavily on the Bible. As I rebuilt a relationship with Christ, I also rebuilt a relationship with myself. The next place I found motivation was from fellow veterans. I look up to so many folks who had been in the same hard place I was and are accomplishing amazing things in the veteran community. I strive to be like them by devoting myself to others. And nowadays, my fiancé, Katrine, is an incredible source of strength and inspiration. Everything about her makes me want to be a better man."

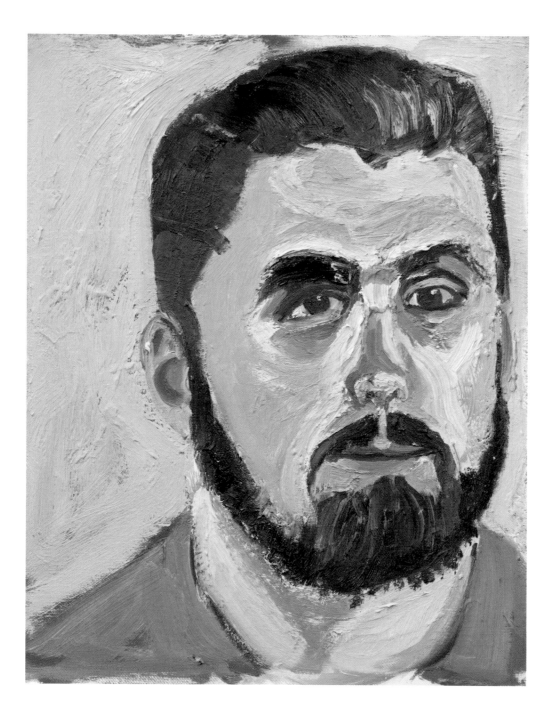

ANDY HATCHER

Andy Hatcher took his oath of enlistment in August 2001, a month before our nation was attacked on 9/11. He grew up in a military family; even as a young boy, he knew what he was meant to do. "Growing up around it, going into the infantry—particularly a reconnaissance unit— was a part of family pride. Every generation of my family has served in our nation's military campaigns," he says.

Andy's Marine Corps reconnaissance unit was deployed to Iraq during the Second Battle of Fallujah in 2004. Insurgents had retaken the city, and Coalition forces launched Operation Phantom Fury to win it back. It was the deadliest battle in the Iraq theater of the war on terror. On Thanksgiving Day 2004, Andy and three of his teammates manned an observation post on the east bank of the Euphrates River. At the end of a rare quiet day, a convoy came to pick up his squad and bring them back to the compound for a turkey dinner. They were ambushed twice on the way. "I got hit in the IED blast during the first attack," Andy recalls. "My guys responded immediately and began rendering aid to the wounded. Everyone caught a little something. My gunny, Gunnery Sergeant Javier Obleas, ended up dying from his wounds a few days later. I went into a coma and didn't wake up until I was at Bethesda Naval a week or so later."

Andy lost his right foot and most of the hearing in his right ear. He also suffered a mild TBI. I presented Andy with the Purple Heart during his stay at the hospital. Remarkably, he wasn't there long. "My recovery was textbook," Andy says. It was accelerated by mountain biking and triathlons. He remains grateful for the care and support he received. "My father is a Vietnam vet. He was treated incredibly differently than I was. We were hoping that wouldn't be something I had to go through, and it wasn't, thank God."

Billy Costello's prosthetic leg wasn't cooperating with him. He'd only had it for a little over a year, and sweat from the Texas heat was causing it to malfunction during our three-day mountain bike ride. Over and over, without fail, he would pull over, readjust his leg, and ride like mad to catch up. On the final day of the ride, I asked, "Billy, did you get that leg fixed yet?"

"Yes, sir!" the Green Beret replied. I wasn't sure if he was just telling his old Commander in Chief what I wanted to hear. I was so impressed by his determination that as we approached the end of the hundred-kilometer ride, Kent Solheim (featured on page 50) and I called Billy up to the front of the pack. I grabbed his hand and thrust it in the air triumphantly as we crossed the finish line together.

Kent and I wanted Billy to finish with us because Billy got his start riding with Kent. Back in 2011, Billy stepped on an IED while on a dismounted reconnaissance patrol in Afghanistan. "The blast took my right leg through the knee from the get-go," Billy says. It also broke his left leg, mangled his right hand and arm, and gave him a TBI. His company commander at the time was Kent Solheim, a leg amputee.

"Kent's friendship and leadership helped me make sense of things in an uncertain time. He had a job waiting for me when I finished my recovery at Walter Reed," Billy writes. "One day, Kent said, 'Billy, get a bike. Let's go ride.'"

Biking opened the door to other pursuits. "I was able to climb Mount Kilimanjaro, descend into the Grand Canyon, climb Aconcagua in South America, traverse a glacier in Alaska, and dive the reefs down in Key West."

Those feats helped Billy realize that he can achieve a lot in addition to what he accomplished in the military. Billy is studying filmmaking at the University of North Carolina and plans to start his own production company.

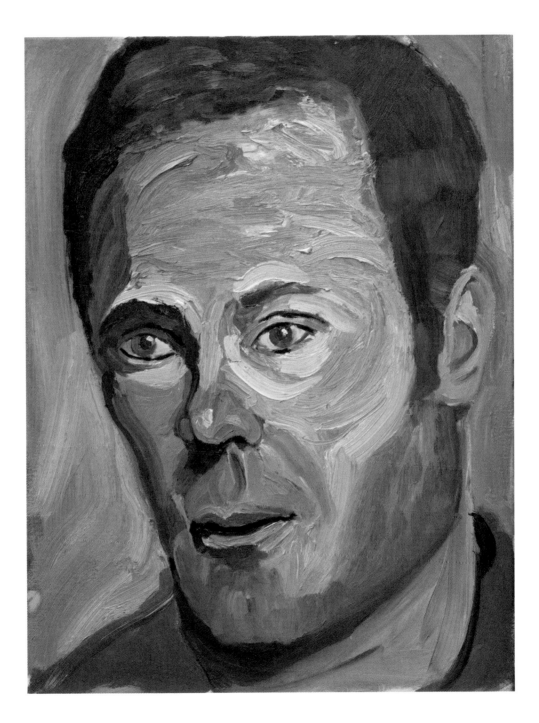

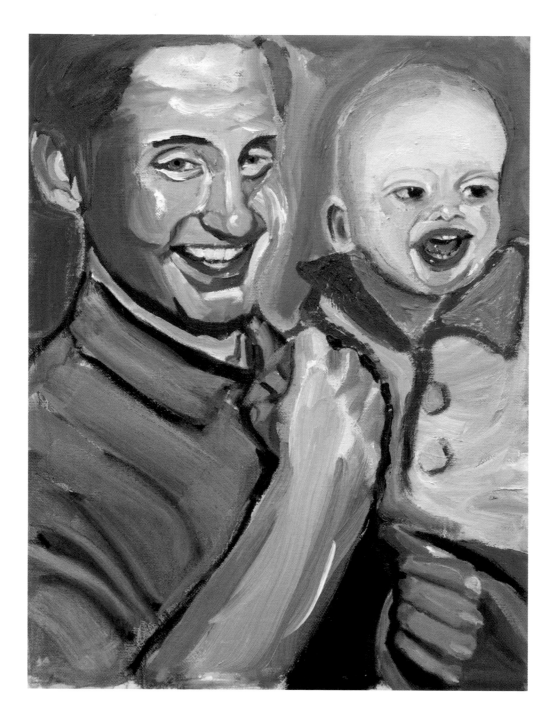

ANDREW W. HILLSTROM

After completing a three-day mission in Iraq, Drew Hillstrom was ready to return to base and get some sleep. But it would be nearly ten years before Drew finally got a good night's rest.

While returning from that mission on September 1, 2007, a bomb activated by trip wire knocked Drew out and severely damaged his right arm. "My right arm has a very limited range of motion as well as limited strength," Drew says. "I was also diagnosed with residuals from TBI and PTS, with the principal symptom being the inability to sleep."

While learning to become left-handed was a big challenge for Drew, the hardest part of his recovery was losing his sense of purpose. "Leaving the military can create a void," Drew explains. Drew was quick to anger—and still couldn't sleep at night. "The thing that helped me the most during my recovery was the realization that in order to fully recover, I needed a new purpose in life," Drew says.

He went back to school, earning his bachelor's degree from the Milwaukee School of Engineering and a master's degree in construction and business management. He got involved with golf thanks to the Salute Military Golf Association. And he started a family.

A few months after Drew played in the 2015 Warrior Open, I received a heartfelt letter from his beautiful wife, Elizabeth. "Life is challenging when I attempt to hold back tears as my husband pretends not to be in pain while picking up our baby," she wrote—adding that Drew is finding new life in new pursuits. "We are a happy, fun-loving family. My warrior has found purpose again . . . to be the best husband, father, son, and golfer he can be."

I recently heard from Drew that part of his purpose includes continued service to his country. As I write this, Drew, along with Elizabeth and their sons Harvey and Dexter, is preparing to represent America abroad as a foreign service officer with the Department of State.

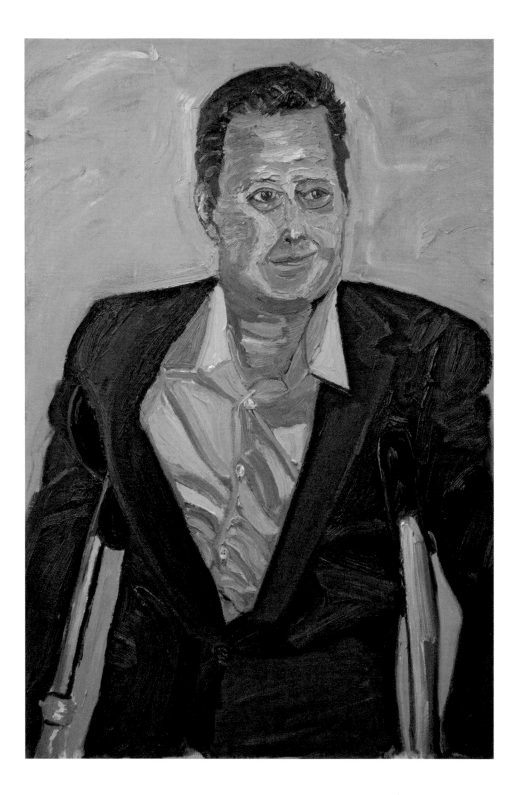

JUSTIN BOND

Justin Bond first joined the Army in 1996, at the age of eighteen. He left a year later to deal with deaths in his family and enrolled in college. After September 11, 2001, he felt the urge to reenlist. He deployed to Iraq, where he was a combat engineer and gunner on convoys supporting the Battle of Fallujah.

On April 9, 2004—Good Friday—Justin's convoy was attacked by insurgents, and he was shot through the center of both knees with an AK-47. "It was not such a good Friday," he says. Justin went through thirty-three surgeries before deciding to amputate his left leg, all the while telling himself, "It will feel better when it stops hurting."

Like so many veterans, Justin feels a familial bond with his brothers in arms. "After my eleventh friend committed suicide," he says, "I knew I had to do something about it." Justin's recovery and well-being had come in large part from the support he got from military service organizations, so he decided to start his own, with the mission of helping veterans get off of suicide watch. Today, Our Heroes' Dreams runs a crisis line manned by volunteer veterans who can relate firsthand to callers and counsel them.

Justin's example, and his sense of pride for his service in the military, can in itself be a source of inspiration and healing for the veteran community. "We were able to save so many women from being slaves in their culture," he says. "After we left, women worked in schools, government, business, and where they wanted to. I am proud to be able to help so many women and children gain their identity in their families. And I am proud not to let my missing leg, PTSD, loss of hearing, and other disabilities define me."

TIMOTHY JOHN LANG

UNITED STATES MARINE CORPS, 2005–2010

Tim Lang grew up with eleven siblings, so he became competitive out of necessity. With his natural athletic talent and sheer force of will, he excelled in every sport he tried, especially on the football field. Later on, the character traits of tenacity and determination that Tim learned on the gridiron would be put to the test in ways he never imagined.

Tim joined the Marines in 2005, inspired by the generations of veterans who came before him. A year later, he deployed to Iraq, where he was severely injured by a roadside bomb. "It killed Sergeant Brock Babb and Lance Corporal Josh Hines, and severely wounded Corporal Josh Bleill, who was also my best friend," Tim says.

Tim spent the next four and a half years in and out of hospitals, undergoing nearly fifty surgeries. His right leg was eventually amputated, and Tim suffered from survivor's guilt, TBI, and PTS. "I would lie in bed and find myself more depressed than I would really let on." He says a breakthrough came when he was introduced to the game of golf. "It has filled the need I had to feel like I can be athletic, I can be a human being, I can do something—and do it just as well as I want."

Tim's wife, Sarah, has been with him since he was twenty-one—through all the ups and downs of his recovery. As I write this, they are expecting their first child, ten years after Tim's injury. "This brings everything full circle," Tim says. "My greatest responsibility is right around the corner: a chance to share in a brand-new life and teach him the incredible blessing of freedom—and the unimaginable price of it."

Today, Tim enjoys waking up for "an ungodly early tee time," watching the sun rise over the golf course, and reflecting on how happy he is to be alive. "We all have battles to conquer in life," he says, "and that's how we are judged: by how we pick ourselves up and move forward."

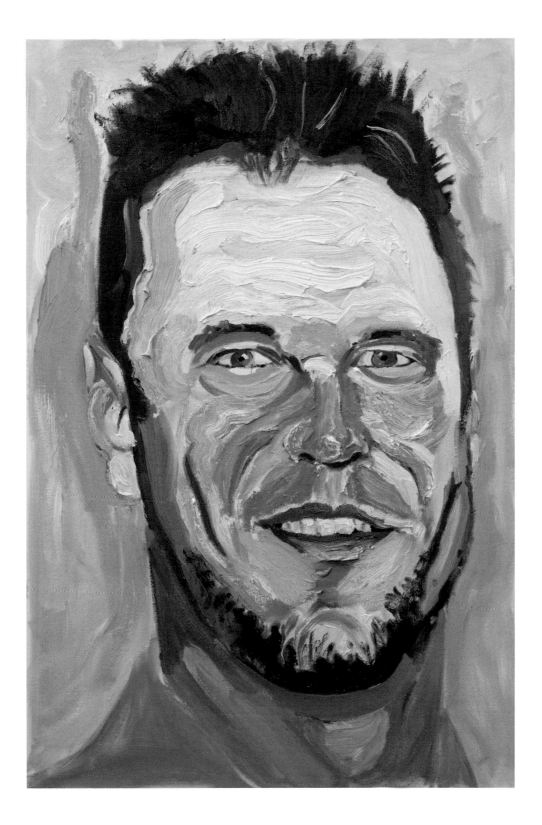

STAFF SERGEANT
ALVIS "TODD" DOMERESE

UNITED STATES ARMY, 1998–2013

"Imagine the worst place you have ever been and
multiply it by one hundred."

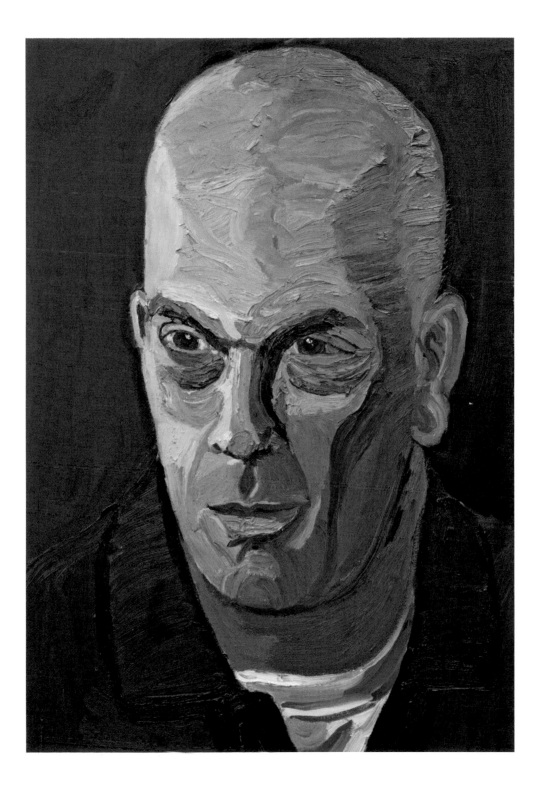

As Commander in Chief, I was always struck by the absence of self-pity among America's Armed Forces and wounded warriors. Having an all-volunteer military helps. But it really comes down to the incredible character of the men and women who choose to wear the uniform of the United States. There is no "Why me?" attitude. More accurately, it's "Put me in, Coach."

But this doesn't mean that combat veterans see through rose-colored glasses, either. More than the rest of us, they see the world as it is. **TODD DOMERESE** served in the Army for fifteen years and was deployed to Kosovo; Iraq, where he was injured; and Afghanistan. He paints a stark picture of the horrors of war and the trials of transitioning back home. I felt it was important to share Todd's story with you, in his own words.

In Iraq, things were terrible. We went weeks without a hot shower. We didn't always have hot meals. We were scared for our lives every day and night. The biggest highlight of each night was knowing that we survived another day.

I had a buddy who was only twenty-one and was shot in the neck and is now paralyzed from the neck down. One of my leaders had his leg blown off and now walks with a prosthetic leg. There was stinky garbage everywhere. There was poverty like you can't even fathom. I saw bloody and burned dead bodies in the streets. There was stagnant water with bugs and raw sewage here, there, and everywhere. Imagine the worst place you have ever been and multiply it by one hundred. Then add to it that we were being hunted like a buck in the woods.

On December 27, 2004, while my team was on a routine patrol in a three-vehicle convoy, tragedy struck. My vehicle was struck with two IEDs simultaneously. One of the bombs was a ball-bearing IED that sent thousands of small metal fragments everywhere, including many spots on my face, head, neck, and arm.

The blast threw my vehicle across the road. It killed my gunner instantly. It tore my driver's arm apart. And it changed my life forever. A large piece of metal came through the windshield and nearly went through

every layer of my Kevlar helmet. The shrapnel hit my head so hard that it fractured my skull. It caused contusions and swelling on my brain.

For the next six months, I was completely dependent on my wife for basic care. I had suffered a traumatic brain injury, so my vertigo and dizziness were severe. My headache pain was unbearable. I was confused and could not remember much of anything. I was definitely not myself. On top of all of the physical problems I was having, I was suffering from the effects of severe depression and post-traumatic stress disorder. I completely isolated myself from the world. I was trapped in my own prison in my head, and I had put a cage around my heart. At one point, I even contemplated leaving the world permanently.

After a few months of this behavior, my wife and children could no longer bear to be around the monster that I had become. I realized that my untreated invisible ailments from war were affecting my family and rubbing off on my two sons. It was then that I knew that I had to do everything I could to get better. I finally sought help.

I'm proud of Todd for his courage to seek treatment for his wounds. And I'm grateful to Todd for his willingness to share his story with others, so they too can start to heal and resume full, healthy, productive lives.

SERGEANT
ROBERT K. LEONARD

UNITED STATES ARMY, 2003-2007

I met Robert Leonard at Brooke Army Medical Center in January 2006, weeks after he lost his right leg in combat. Ever the soldier, he wanted to stand as his Commander in Chief presented him with the Purple Heart, so I helped him out of the wheelchair for the emotional ceremony. When I looked back at photos from that moment, I saw that Robert had put on quite a brave face. I, on the other hand, wasn't able to hold back my tears. So imagine how pleased I was when Robert visited my ranch in 2014 to ride mountain bikes. I was so proud to see how far he had come—and glad for the chance to retake our picture.

Robert's grandfather, father, uncles, and cousins served in the Armed Forces, so he says signing up for the Army in 2003 was a natural move for him. Of course, he had no way of knowing that a roadside bomb would go off under his Bradley Fighting Vehicle, taking his right leg in the blast.

"My amputation was easy to recover from," Robert says. "But getting your mind right after these events is what really takes a toll." The expectation of being a "really tough soldier" kept Robert from seeking the help he needed. It wasn't until he learned about the Lone Survivor Foundation, started by former Navy SEAL Marcus Luttrell, that Robert found treatment for his PTS and got his life back on track. "They are just unbelievable for therapy," he said in 2014, "and I've been under their wing for a while now."

Robert found another form of therapy when his daughter, Kamryn—who was born while he was in Iraq—asked him to ride bikes with her. When Robert isn't riding bikes with Kamryn, watching his son Wyatt's football and baseball games, or attending his wife Lacey's volleyball games, he is at work as a homebuilder or in his woodshed making custom furniture. He dreams of starting his own homebuilding company one day.

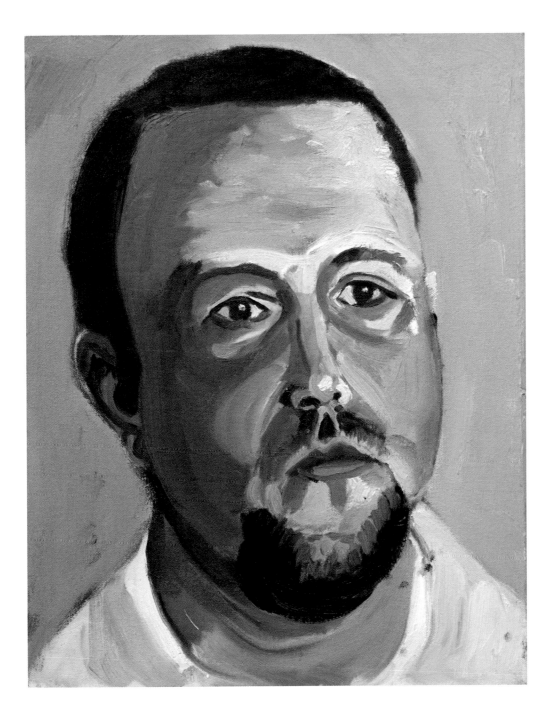

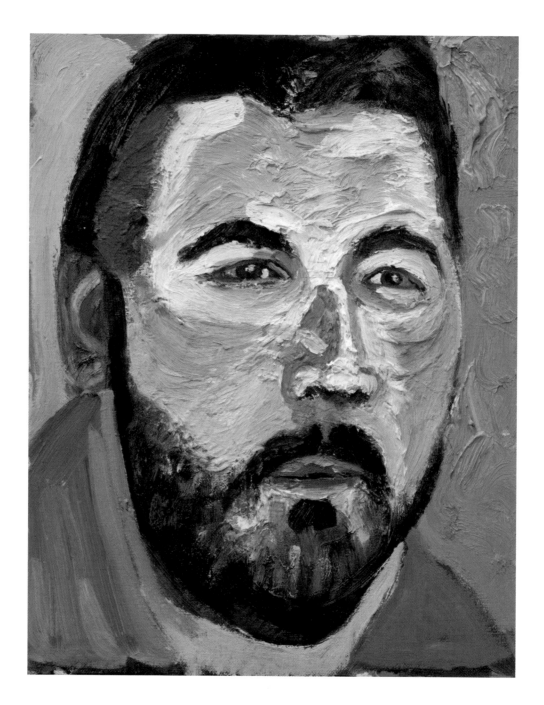

JACOB LERNER

After Jake Lerner's truck hit an antitank mine in Afghanistan, he couldn't believe he was alive. His platoon sergeant was thrown from the vehicle during the huge explosion, and his medic was severely wounded. Miraculously, Jake—who was in the gunner position, often the most dangerous part of the vehicle—was okay. "I got my bell rung pretty good, but no serious injuries," he says.

The next morning, he stepped on a land mine.

"I didn't know how bad it was until I looked at myself and noticed my arm had been blown apart pretty good," he says. "I've never seen myself bleed that much." Jake lost his right foot at the ankle. His lungs started to fill with blood, and he felt like he was suffocating.

Jake was flown to Germany. He didn't think he would survive. "Then I took a real long flight back to the States, where I rehabbed at Walter Reed," he remembers. "Luckily, I had the best people helping me recover. You can't even tell I'm an amputee."

During Jake's eighteen-month stay at Walter Reed, he got to know Dillon Behr, an injured soldier who was also recovering there. "He got me into mountain biking. I went out and bought a cheap mountain bike, and I got my butt handed to me," Jake jokes. But he stuck with it. "Go big or go home," he says. "Mountain biking became the healthiest mental recovery and therapy I could get—and I needed it."

At our first W100K mountain bike ride, at Big Bend Ranch State Park in southwest Texas, Jake said, "That's why we're here: to face the challenges and prove to everybody that just because we're injured, we don't just sit on the couch and collect a paycheck. We're out here getting after it." My hope in painting Jake was to capture the determination he expressed in those words.

Jake has since become a father. His young son, Titan, is fortunate to have such an example and inspiration as his dad.

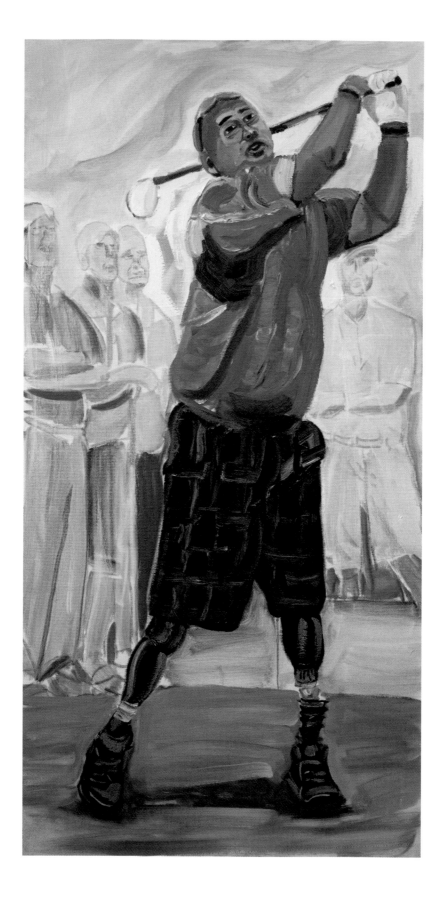

SERGEANT
SAUL MARTINEZ

UNITED STATES ARMY, 2006–2010

When Saul Martinez lost both his legs in Iraq, his wife, Sarah, became a model of patience and support. "She never left my bedside," Saul says. "She motivated me." One day, that motivation came in the form of tough love. "About six months into my recovery, I was on the couch relaxing like usual, and she asked me to vacuum the house." Still wheelchair-bound, Saul expressed disbelief. "Umm, how am I supposed to do that?"

"She told me something that's very significant to me, even today: 'Figure it out!' From then on, any obstacle for me has been a matter of figuring it out or adapting to a situation," Saul says.

Saul lost more than limbs in Iraq. The IED attack that stole his legs also took the lives of his two close friends. Adjusting to his new anatomy was hard, but Saul says, "By far the most difficult was watching my buddies get killed in action and being the last one to ever see both of them alive. That was tough, and still is for me every hour of every day."

Learning to walk again and eventually helping other wounded soldiers in an Army warrior transition unit helped him get his mind off the survivor's guilt—for a while. Eventually, the pain of the loss led Saul to accept that he could no longer remain in the Army.

"What do you do after you had your dream job as infantryman and you can't do it anymore?" Saul asked aloud. Well, Saul figured it out.

A fly-fishing outfitter called Warriors and Quiet Waters brought Saul on a trip to Montana, where he fell in love with the outdoors. He and Sarah decided to move there. Saul earned his bachelor's degree from Montana State University and took a full-time job with Warriors and Quiet Waters. He says you can usually find him outside with Sarah and their children—but admits that he sometimes still enjoys relaxing on the couch, too.

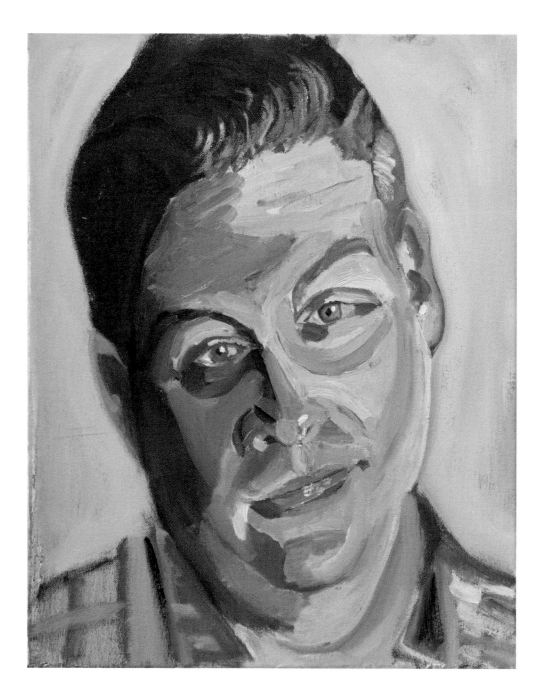

JOSHUA MICHAEL

UNITED STATES ARMY, 2009–2013

When Josh Michael deployed with the Army to Afghanistan, his unit accounted for the most Purple Hearts and fatalities in the war. On September 8, 2011, Josh added to that unfortunate tally.

Josh was manning a traffic control point when, as he tells it, "a madman with a mortar tube started lobbing rounds at our small base." During the attack, a mortar landed just five feet away from him. "My left leg and arm were destroyed," he says. Josh's platoon laid down enough suppressive fire for a helicopter to medevac him. He spent one month in the hospital and the next eighteen in and out of surgeries, physical therapy, mental therapy, and occupational therapy.

Josh says leaving deployment is "like coming down from an extreme high, and you get depressed." He adds, soberly, "Anyone who has seen real combat will have invisible wounds of war." Josh receives treatment for his PTS, and it's helping.

Another key part of Josh's support system is his church. "I've been in church my entire life," he says. "My faith and my belief in Jesus gave me complete confidence I would come out just fine. My church in San Antonio helped me a lot to reintegrate with people and interact like a normal person again." He also benefited from a friend named Kyle who selflessly quit his job to take care of Josh when he was confined to a wheelchair.

With help from above and from the people around him, Josh got back on his feet. He bought a mountain bike to get back in shape; now he enjoys introducing his fellow veterans at church to some of San Antonio's best trails. He works as a successful sales rep for a company that is smart enough to hire veterans, and he just bought his first home with his wife, Brittany.

"I always say getting hit was the best thing to happen to me," Josh says. "Every day is a blessing."

SPENCER C. MILO

Spencer Milo joined the military in 2006 as an Airborne Infantryman. In 2008, he sustained injuries in Iraq that led to the discovery of a tumor in his brain. The prognosis was not good. He was given six months to live. Fortunately, that diagnosis was wrong. The tumor was removed, giving Spencer a new lease on life. He chose to use it to continue serving in the United States Army. Spencer embarked on his second combat deployment, this time to Afghanistan. In January 2011, he was injured again in a horrifying way: a child suicide bomber detonated eight feet from Spencer.

After six months of physical and medical rehab at Fort Bragg, Spencer was sent to the National Intrepid Center of Excellence, or NICoE—"the military's primo TBI and PTS treatment facility," he says. Part of what made his treatment so effective was that it included his wife, Sarah. "It ensured we were on the same page so she could help me as best as she could," Spencer explains. "Before, the amount of miscommunication and lack of communication (mostly my fault) was causing some major issues." The experts at NICoE helped Spencer rehabilitate with the therapies that worked best for him. Mountain biking was effective. Getting off of prescriptions helped a lot. And family was at the top of the list.

"When I found out that my wife was pregnant with my daughter, I remembered an emotion I had overseas: 'In order to take care of others, you have to be able to take care of yourself.' It gave me a new and reinvigorated motivator to get better and allow myself to heal."

As Spencer's healing accelerated, he attended a workshop put on by Hire Heroes USA, an organization that helps veterans find work in the private sector. As it turned out, Hire Heroes USA hired him. "I focus on helping service members, veterans, and military spouses transition into the civilian workforce," he says. "I have dedicated my life to serving my fellow brothers and sisters."

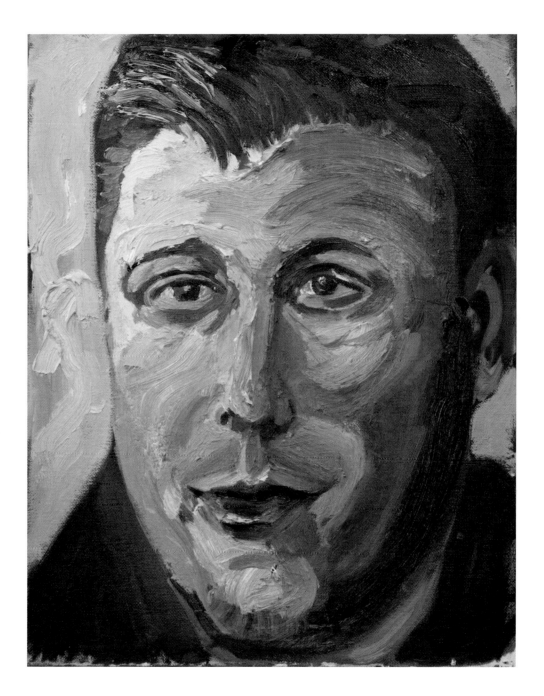

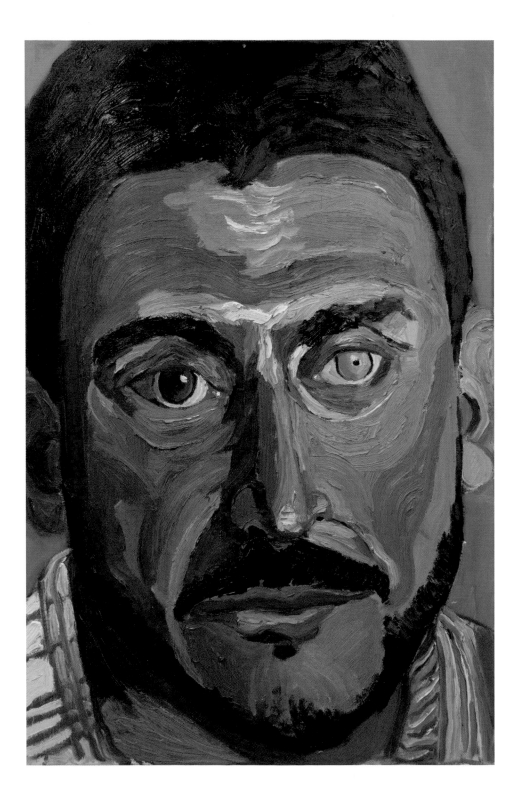

MICHAEL R. RODRIGUEZ

UNITED STATES ARMY, 1992–2013

"I was able to assist foreign soldiers in defending their homelands.
I had the opportunity to watch a little girl go to school for the
first time because of the security I provided."

I think Bono and **MICHAEL RODRIGUEZ** might be the only people who've ever worn sunglasses during dinner with Laura and me. (I don't normally name-drop, but Michael gave me permission.)

Michael—I call him Rod—joined the Army in 1992 and became a Special Forces Green Beret. His job took him to Somalia, Haiti, Colombia, Panama, Peru, Bolivia, and twice to Afghanistan, where he represented our military's might and our nation's heart. "I provided medical care to a child who had never received any type of medical care before. I witnessed a malnourished child eat after weeks without a meal," Rod says.

It wasn't all uplifting, though. Throughout his nine deployments over twenty-one years, Rod and his mates hunted down a lot of terrorists and saw some tough combat. He can count at least a dozen concussions, three of which came within a five-week period during his 2006 tour in Afghanistan. As the senior medical officer for his unit, Rod hid his injuries. "I had hopes that my double vision, severe headaches, light sensitivity, dizziness, and balance would improve with time," he explains, "so I continued to hide my symptoms until they became a hindrance to my duty performance." When the symptoms caught up to him, Rod was diagnosed with severe PTS and TBI, which resulted in his medical retirement from the Army.

"I felt as though I had lost my identity when I was told I could no longer be a Special Forces Green Beret," he says. "I became chemically dependent on alcohol and pain medication. I rarely left my house or even went to the store." At night, he sometimes heard the screams of the women and children he couldn't save. To deal with the light sensitivity and the trouble it gave him reading and focusing—a symptom of his TBIs—he started wearing dark sunglasses, even while indoors. Rod noticed that no one would approach him or talk to him while he was wearing the glasses—a side effect he enjoyed. The shades became a crutch, a "shield" to hide behind. His wounds were invisible, and he wanted to be invisible, too. After a while, the only time he took them off was when he went to sleep at night.

One morning in 2015, the year after Rod first rode and dined at our ranch, the youngest of his three sons saw him without his sunglasses. Jacob shouted, "Daddy, I can see your eyes!" The joy in those words became the emotional lifeline that pulled Rod back from the abyss. He found an optometrist who prescribed prosthetic lenses. The blue-green lens corrects his double vision; the tinted lens helps with his light sensitivity. Because the lenses are different colors, Rod made for a very interesting subject to paint.

Like most everyone with PTS, Rod's treatment is ongoing. Unlike most everyone with PTS, he is married to a combat veteran who experiences it herself. Rod and Kelly make unique partners who can comfort and strengthen each other. They push and encourage each other in physical activities like mountain biking (Kelly rode in the 2016 W100K) and CrossFit. Rod also finds peace in blacksmithing. "There is something beautiful about getting a piece of metal, heating it up, and repurposing it. In those moments when I am making something," he says, "that is all that matters."

Rod is very talented. Prince Harry and I are proud owners of beautiful daggers that Rod forged for us. But I'm most proud of the friendship Rod and I have forged, of his service on my Institute's Military Service Initiative advisory board, and of his courageous contributions to our country and the world.

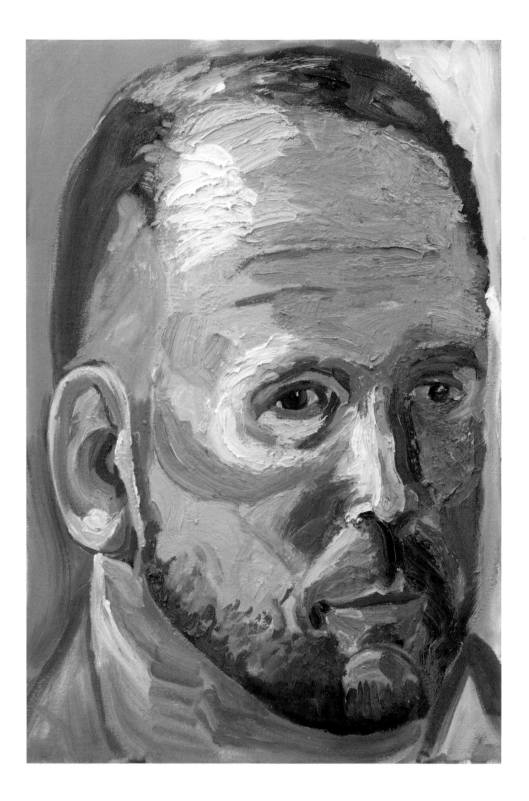

DAN NEVINS

UNITED STATES ARMY, 1991-1999

ARMY NATIONAL GUARD, 1999-2006

If you were to go back in time and tell eighteen-year-old Dan Nevins that in twenty-five years he would be an internationally sought-after public speaker and yoga instructor, there's a good chance he'd have called you crazy. Dan signed up to join the Army in 1990 during his senior year of high school. "I said, 'I'm going to fight,'" Dan remembers. "Then the Gulf War was over before I even graduated. But I still honored my commitment." He served on active duty for eight years. When he left to earn his bachelor of science in business administration from Sonoma State University, he continued his service with the National Guard. "I just couldn't give up that uniform," he says.

Dan was mobilized and deployed to Iraq in 2004. That November, an IED detonated under his vehicle, taking Dan's left leg, severely injuring his right, and giving him a traumatic brain injury. In the months that followed, Dan's doctors at Walter Reed did everything they could to save his right leg. "My surgical team was amazing," he says. Unfortunately, after more than thirty operations and a recurring bone infection, Dan was faced with his next challenge: adjusting to life as a double amputee.

Dan has built an impressive résumé in the years since his injuries. He worked as a successful pharmaceutical sales rep at Pfizer, was hired by the PGA Tour to help establish their military and veterans programs, and ultimately became a program director and spokesman for the Wounded Warrior Project. Inside, Dan felt like he was still struggling.

"Later," he says, "it was yoga and meditation that have helped me heal completely and find my new purpose." For two hundred days a year now, Dan is on the road teaching, speaking, and inspiring others with his journey. "I'm committed to sharing the healing power of yoga and to getting as many warriors and veterans on yoga mats as possible," he says. "The power to heal, completely, is available right now."

FIRST LIEUTENANT
DENIS OLIVERIO

UNITED STATES MARINE CORPS, 1987–2007

In 2002, Denis Oliverio graduated from Embry-Riddle Aeronautical University with a 4.0 GPA. When he addressed his graduating class as a staff sergeant and valedictorian, he thought about how far he had come in the fifteen years since leaving Somerville High School outside of Boston without graduating.

Denis joined the Marine Corps in 1987 as a helicopter mechanic. He earned his wings, flew as a crew chief with the Black Knights, deployed to Iraq during Operation Desert Storm, and served as a test flyer for the Marine Corps' Osprey program, an airplane that can convert into a helicopter for vertical takeoffs and landings.

In 2005, Denis returned to Iraq, this time as an officer in command of a tank platoon. "On October fourteenth," he says, "I was engaged with some insurgents and trying to maneuver some of my forces. Communications were just clobbered. When I couldn't raise my wingman over the radio, I did what we were trained to do: use hand and arm signals." When Denis raised his left arm out of the tank, a bullet shattered his bone and severed the artery and nerve. It took fifteen surgeries, three titanium plates, twenty-three screws, three vein grafts, and three nerve grafts to save Denis's arm.

"Other than God and family," Denis says, three things helped him recover: golf, his service dog, and riding horses with his daughter. He now golfs competitively. "Not being able to serve as a Marine anymore takes the wind out of your sails and leaves you lacking the adrenaline that you were used to for decades. Competing at the Warrior Open filled that void and provided me with an avenue to rehabilitate my arm and my mind, which is a work in progress," Denis says.

At the Open, the Grammy-winning country band Rascal Flatts generously gave of their time to entertain the veterans. When they played their hit song "Bless the Broken Road," Denis and his wife, Katie, were the first ones on the dance floor. It was their wedding song.

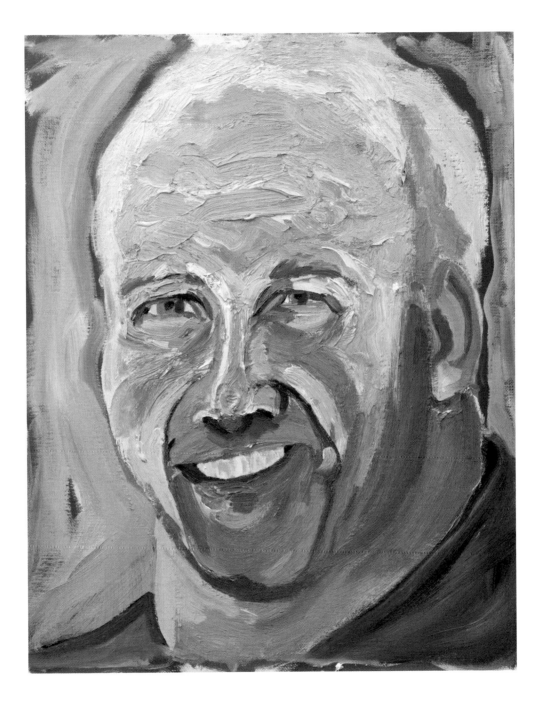

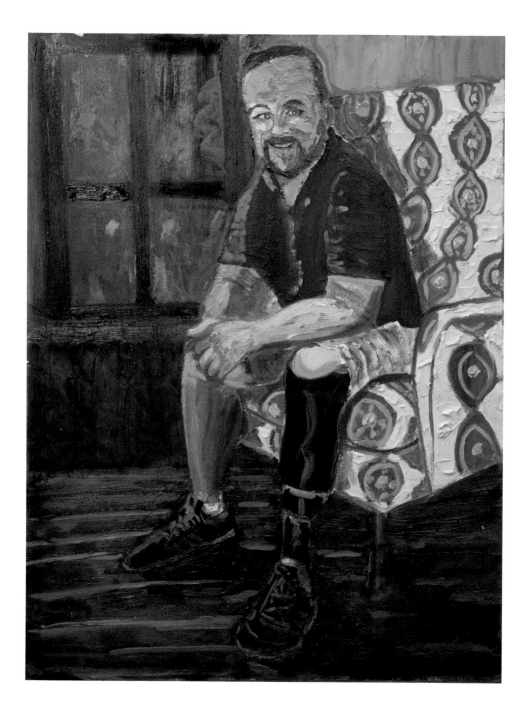

WILLIAM J. GANEM

I call BJ Ganem "Belushi." I kid with him that it's only partly based on his appearance; it's mostly because he's one funny dude.

"In high school, I was voted least likely to join the military," BJ jokes about his background. "At college, I was more interested in partying than studying, so I was politely asked to leave on academic probation." He wanted to break the news to his mother easy, so he enlisted with the Marines. "I joined the military to show her I had a plan."

After four years on active duty, BJ got a job at Kraft Foods. To continue his service, he re-enlisted with the Marine Corps Ready Reserves. In 2004, he was activated and sent to the Al Anbar province of Iraq. On Thanksgiving night that year, BJ's Humvee was blasted by a roadside bomb, killing one man and severely injuring three others. BJ's legs were badly damaged, and his left leg was eventually amputated. His left eye is scarred and his ears still ring. He has been diagnosed with TBI and mild PTS.

"I was angry that I didn't finish the deployment, that I was no longer a Marine infantryman," he says. There were other setbacks, too. His marriage fell apart. He filed for bankruptcy. He was arrested for DUI. In short, BJ hit rock bottom. He took a long look in the mirror and made the decision to seek help. As BJ puts it, "I wanted to see what I could accomplish when my head was removed from my ass."

BJ can see clearly now. He got into athletics—hand cycling first, which led to running, then mountain climbing, dogsledding, snowboarding, golfing—you name it.

BJ changed his career path, dropping his business management major and earning a bachelor's degree in psychology from Saint Leo University and a master's in social work from USC with an emphasis on military life. Today, he is an accredited veteran service officer working for the Semper Fi Fund, which helps smooth the transition for combat veterans so they can continue to contribute to society as civilians.

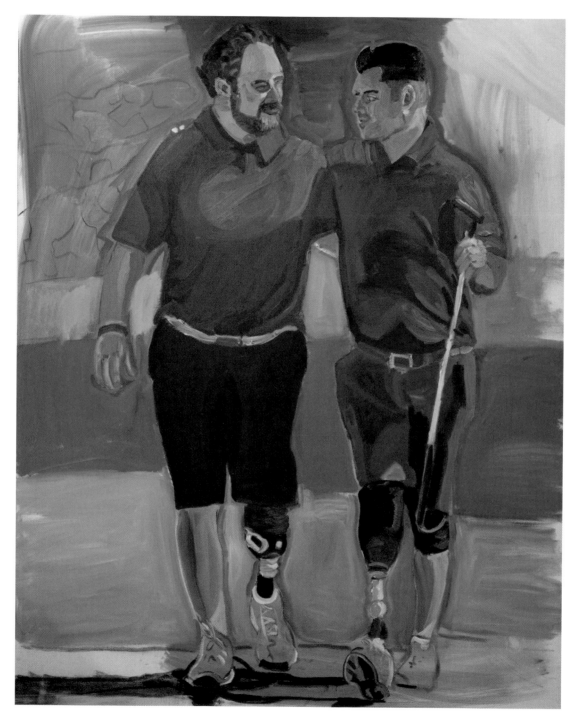

BROTHERS IN ARMS

STAFF SERGEANT
JACK SCHUMACHER

UNITED STATES ARMY, 2005–2011

(AT RIGHT)

"I learned early on that you had to be able to
adapt to anything that was asked of you."

WILLIAM J. GANEM

(AT LEFT)

(SEE PAGE 137)

After I met **JACK SCHUMACHER**'s father in 2015, he sent me a letter. "Isn't it amazing how the things that present themselves as the worst actually contain within them the seeds of being the best?" Jack's father wrote. "So it was with Jack. It isn't so much his physical recovery or even his bravery under fire that I'm so proud of. Rather, it was his decision to reject victimhood—not allowing his injury to be the end of his story, but rather the catalyst to a new and triumphant story."

Jack Schumacher would make any father proud. After his sophomore year of college in 2005, Jack came home for the summer ready to goof around with his childhood friends. "But something was different," he says. "I felt something starting to stir inside of me. I realized that as I would be relaxing in the summer sun, there were men and women my age preparing to serve their country. I knew that enlisting in the military would be the first truly selfless decision of my life." Jack joined the Army, he remembers, "with a new sense of pride in having the honor to raise my right hand and swear an oath to serve my country, as generations of Americans had done before me."

Jack deployed once to Iraq in 2006 and once to Afghanistan in 2009. "I learned early on that you had to be able to adapt to anything that was asked of you," he says. "During both of our deployments, we were decentralized from other units in our brigade, meaning that we had to learn and be proficient at new skills such as construction, plumbing, automotive repair, and first aid."

In May 2009, Jack's convoy was ambushed in southeast Afghanistan. "I watched as an RPG was fired directly at my vehicle, piercing the armor and detonating on my right leg," Jack remembers. "When the smoke cleared, I saw that my leg was completely severed.

"When I got to Walter Reed, I was shaken to the core—physically, mentally, emotionally, and spiritually," he says. "I remember just staring out my hospital window for hours, kind of numb." Fortunately, that didn't last long. Jack describes Walter Reed as "a special place where people took a vested interest in helping rebuild [his] life." He says, "It's hard for me to put into words the amount of respect I have for all of the doctors, nurses, and therapists who helped me recover. Not only were

they able to repair my physical wounds, they also helped me heal emotionally."

As Jack became accustomed to his new prosthetic leg, he threw himself into physical activities and therapies, from snowboarding—something the Champaign, Illinois, native never expected to do, even when he had two legs—to kayaking, cycling, and golf. Jack took classes at night after his physical therapy and medical appointments, and in 2014, he graduated with honors from Georgetown University's McDonough School of Business. He was hired out of school by Under Armour and now works for the sportswear company as a business analyst for global supply chain operations.

At the end of a three-day bike ride from Washington, DC, to Annapolis, Jack met a girl named Jill. "As cliché as it sounds," Jack says, "it was love at first sight." In a happy ending more befitting of a fairy tale than a nursery rhyme, Jack and Jill married five years to the day after they met. "She holds me up when I'm not strong enough to stand on my own," he says. "She inspires me to be a better man, and she opens my eyes every day to how wonderful the world is."

I call this painting of Jack and BJ Ganem *Brothers in Arms,* a testament to the unique way that veterans help each other heal through camaraderie and mutual support.

OMAR ROMNEY

Omar Romney suffered physical injuries in Iraq, but he will always be more haunted by what he saw there. Omar was part of the liberating forces who arrived to topple Saddam Hussein's dictatorship in early 2003. Conditions inside the country under Saddam's regime were deplorable. "People are hungry, and you can see it. They'd try to climb in our vehicles to get our rations," Omar says. "Sometimes the adults would beat the kids to try to take stuff from them. They pushed one in front of our vehicle. To avoid the kid, we went into a ditch and my vehicle flipped over. After that, I don't remember much."

Omar was medically evacuated to Kuwait, then to a hospital in Spain, before finally arriving at Fort Campbell, where his recovery began in earnest. Today, Omar describes his injuries modestly: "I have a few scars, but nothing major." A closer look at the list reveals a spinal cord injury, TBI, PTS, fibromyalgia, migraines, and mild paralysis of his arms and legs.

Once he left the hospital, Omar had to walk with a cane. The PTS was debilitating, and he hated the fact that he had to leave his unit behind on the battlefield. "That was the hardest part for me," he says, referring to his medical retirement. "Knowing that I was home while they were still out there. I was a lifer. I would have stayed in fifty years if they let me."

About his recovery, Omar says, "It's been a long process that I'm still dealing with." Eventually, he just got tired of feeling sorry for himself and decided he wanted to get better for his family's sake. When Ride 2 Recovery offered to teach him how to mountain bike, Omar was "psyched up," as he puts it. "It was the best thing that ever happened to me. I feel strong, mentally and physically. I haven't used my cane again."

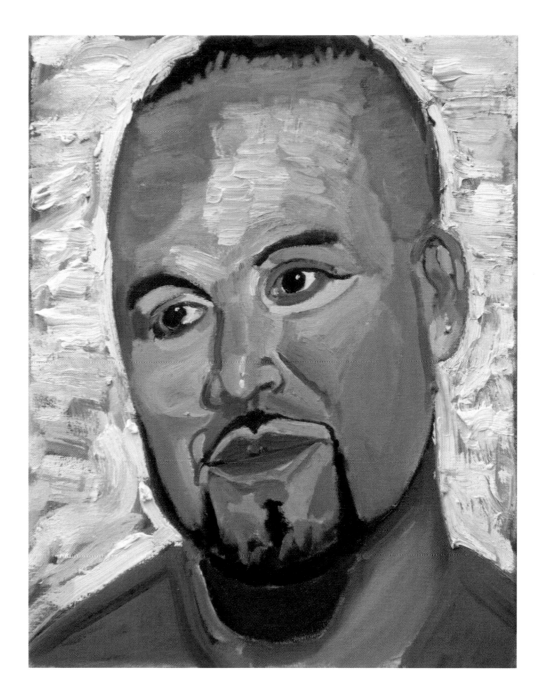

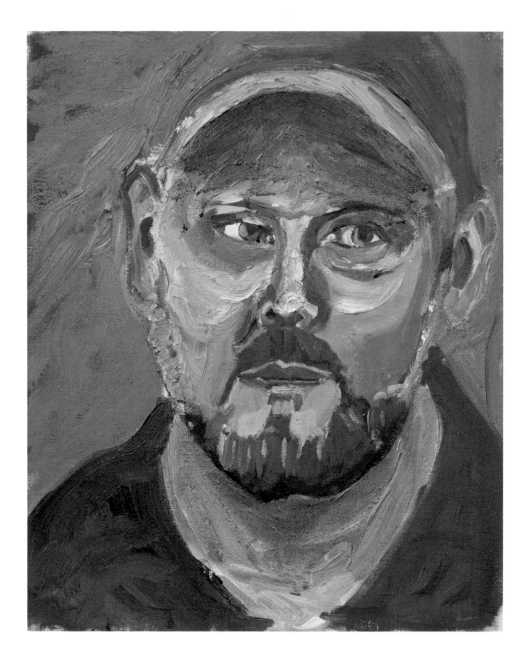

LEE SAGE

UNITED STATES NAVY, 2002-2006

UNITED STATES ARMY, 2010-2013

When Lee Sage joined the military in 2002, he was carrying on his family's tradition of service. Lee's parents didn't serve in the Armed Forces though. They were missionaries. Lee was born in Papua New Guinea, where his mom and dad worked as Bible translators.

Upon graduation from high school, Lee chose to serve mankind in the United States Navy. Onboard the USS *Peleliu* in the Persian Gulf, he was responsible for loading ordnance on aircraft launching missions in the war on terror. Lee fulfilled his commitment and was honorably discharged after four years. But he was left wanting to contribute more, so he re-upped—this time as an infantry gunner in the Army.

On May 8, 2011, Lee was shot by a sniper while manning his combat outpost in the Kunar province of Afghanistan. "He got me in the gut," Lee says. "The bullet went through my stomach, intestines, and shattered my sacrum into twenty or so pieces. I was paralyzed from the waist down on the right side for about three weeks."

Lee was evacuated to Fort Campbell, where he learned how to walk again. "That wasn't easy," he says. With servants' hearts, his family rushed to his side. "I told my mom to leave. She said, 'No, I'm not leaving. You're my son.'" His parents and siblings provided love and encouragement. And with their support, Lee recovered to the point where he could play golf, and even baseball "every now and then."

Lee has been diagnosed with PTS. "Smells, sounds, or just a thought can trigger it," he says. He still has nerve damage on his right side from the waist down, too. But none of that has held Lee back. "In many ways, I am still working through my recovery," he says. "It hasn't been easy by any means, but I wouldn't trade it for anything." I hope my painting captures Lee's determination and drive to recover from his wounds.

JOSÉ E. SANTIAGO

For José Santiago and so many of his brothers and sisters in arms, losing the camaraderie that comes with military life is the hardest part about leaving the service. For José in particular, the challenge of the transition was compounded by an additional factor. "I came back to an empty home," he says. "My family left me."

José joined the Army in 1999. During his deployment to Iraq in 2003 and 2004, he was hit by an IED but spared any severe injuries. Or so it seemed. As a medic who treated countless physical wounds during his deployment, he thought he knew what injuries looked like. It wasn't until he got home to that empty house that he learned about the invisible wounds of war.

"When I came back, I came back a little different," he says. "I came back drinking a lot and doing things that weren't me, that weren't normal. I had nightmares. I was acting out of character and being aggressive. I had no idea I was suffering from PTS." José had seen people die while under his care, including one of his friends, Jesse Givens.

José made the decision to check himself into the hospital. He went to the VA in Colorado and was diagnosed with severe chronic PTS as well as TBI. The treatments helped. What he found most effective, however, was cycling. "Every time I ride, even though I could be hurting—once I'm done, I feel a sense of accomplishment," José says. He is still on his bike every day and loves participating in group rides with his fellow vets. "This is the closest I get to being back in the military," he says.

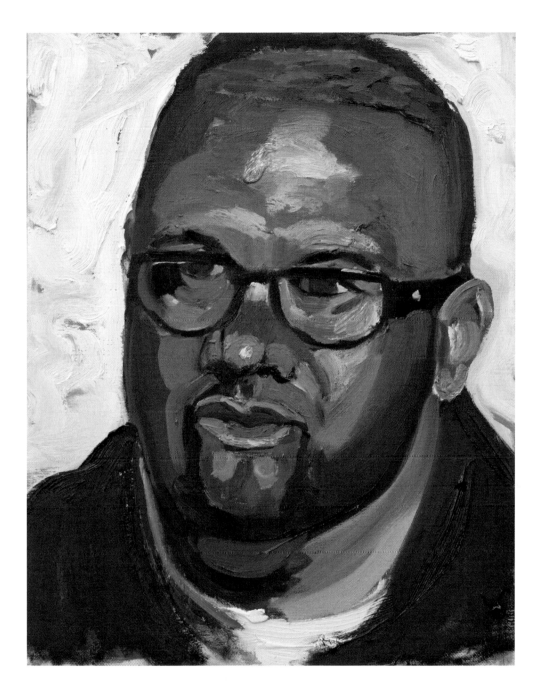

JAMES M. STANEK JR.

On September 11, 2001, Jim Stanek was a first responder at the World Trade Center. He was there as a volunteer with his local fire department, helping as the work transformed from a rescue mission to a massive cleanup operation.

After seeing the tragedy and devastation firsthand, Jim says, "joining the Army to defend this great country of ours was easy." Jim deployed to Iraq three times. He endured more firefights and IED explosions than he can remember. "I had surgery on my right shoulder and right hand," he remembers, "and I was medically retired with PTS and TBI.

"Recovery was a rough road," Jim says. "Simple tasks like going to get groceries were rougher than being in a firefight." The medications he was prescribed didn't seem to help. He felt like a zombie, and he struggled with anger and trust issues. "I thought everything was a threat."

That all started to change when Jim went on a hunting trip with Cody Hirt, co-founder of a group called Veteran Outdoors. "Cody over the years brought me back to God. Trust me when I say it was a bumpy road, but without him I don't really know if I would have come back to our heavenly Father," Jim says.

Jim also benefited from the companionship of his service dog, Sarge—so much so that Jim has devoted the past few years of his life to helping other veterans get dogs and even appeared on a popular television show called *Dogs of War*. "My mission since I left the service has been to help my brothers and sisters in need," he says. "I am out of the war, but I am not out of the fight. I will not quit."

My painting of Jim reflects the anxiety that I sensed in him when we first got to know each other. If I were to paint him again today, the portrait would reflect a more settled soul.

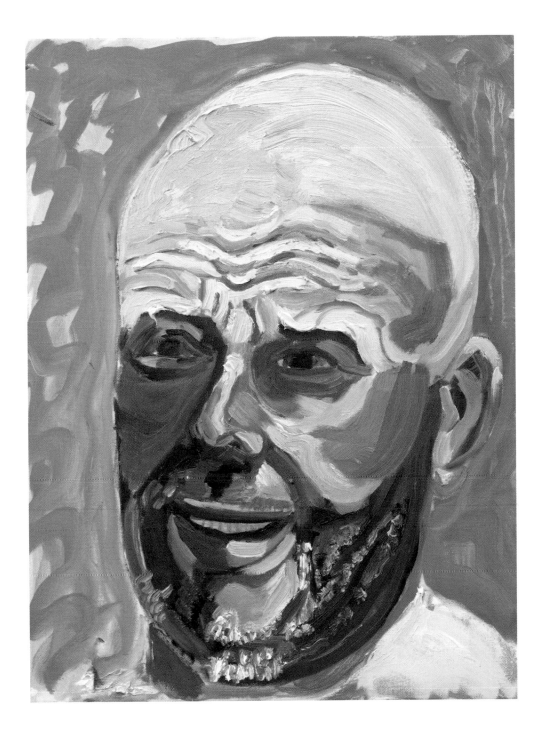

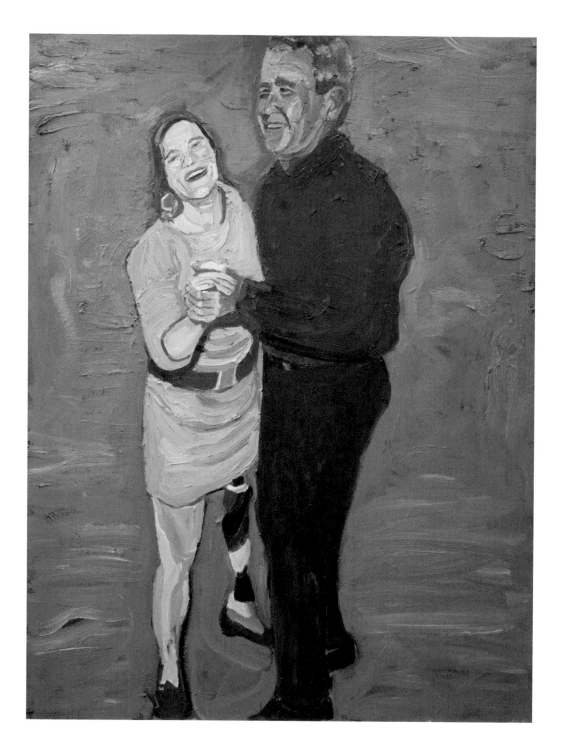

FIRST LIEUTENANT
MELISSA STOCKWELL

UNITED STATES ARMY, 2002–2005

———————————————

"I joined because I love our country, short and simple."

MELISSA STOCKWELL's Army service began in an ROTC program during her sophomore year at the University of Colorado. "I joined because I love our country, short and simple," she says. "I had a passion for the American flag at a young age. That turned into a desire to wear a uniform with a flag patch on my shoulder. Years later, I proudly put an American flag on my prosthetic leg. I'm proud to show it off, proud of how I lost it," she says with poise and grace.

On April 13, 2004, three weeks into Melissa's deployment to Iraq, her convoy was headed into central Baghdad. As they drove through an underpass, her vehicle hit an IED. A combat medic performed emergency surgery on the scene, stabilizing Melissa and saving her life. She was the first female to lose a limb in the war on terror.

"I was twenty-four years old when I lost my leg," Melissa says. "You never expect it to happen. You never think it's going to be you." She spent a year recovering at Walter Reed. "I looked around and saw a lot of other soldiers who were much worse off than I was. We were all trying to find our new normal. I really considered myself one of the lucky ones. I used their resilience as motivation. I wanted to live my life for those who gave the ultimate sacrifice and didn't make it back at all."

Melissa benefited from a loving family who was by her side from day one. An eternal optimist and lifelong athlete, she says the hardest part was waiting for her body to heal enough that she could get moving again. "Getting back in the pool, learning to ride a bike again, they made me feel more like myself," she says. An opportunity to get out of the hospital for a while presented itself through the Vail Veterans Program. Melissa describes going to Colorado and learning to ski on one leg as a eureka moment for her. "Skiing down the mountain with the wind in my hair and feeling so free . . . I went back to Walter Reed thinking, 'If I can do that, then I can do anything.'"

Melissa went back to college and studied prosthetics so she could learn to fit other amputees with artificial limbs. She became a great runner, a great swimmer, and a great cyclist, which she realized made her a great triathlete. Melissa cofounded Dare2tri in Chicago, a nonprofit organization that gets disabled athletes into triathlons. On September 11, 2016,

Melissa represented Team USA in the triathlon at the summer Paralympic Games in Rio de Janeiro. I sent her a message of congratulations when she earned the Bronze medal: "Attaboy, girl!" She said she raced for those who made the ultimate sacrifice exactly fifteen years earlier and in the war on terror since.

Melissa's spirit makes every moment with her memorable. For me, there are three in particular. One came when Melissa and her husband, Brian, brought their infant son, Dallas, to meet me. I saw the pride and joy on Melissa's face that can only come from being a new parent. Another is when we shared a dance together after a tough day on our mountain bikes in Palo Duro Canyon. Perhaps my proudest memory of Melissa is from the dedication of my Presidential Center in Dallas in 2013, when Melissa honored Laura and me by agreeing to be a part of the program onstage. I introduced her to every living President. Then I watched as Melissa led us—along with the crowd of thousands—in reciting the Pledge of Allegiance to the flag she loved and defended.

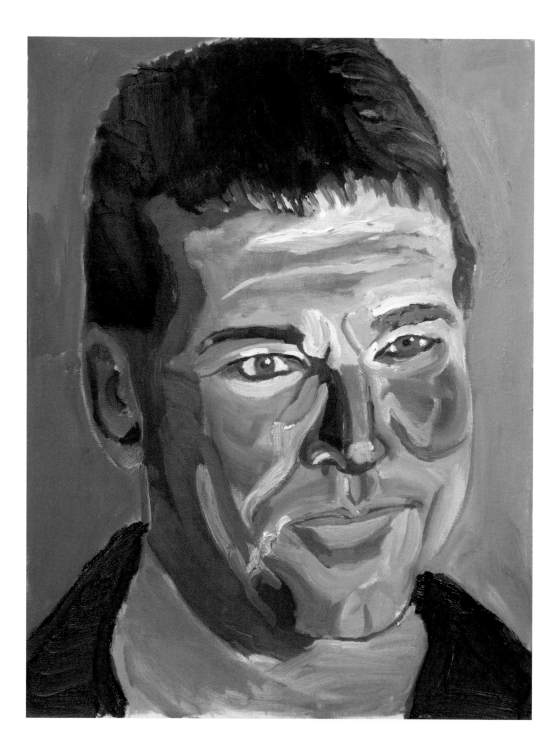

JAMES WILLIAMSON

UNITED STATES AIR FORCE, 1989–1999

UNITED STATES ARMY, 1999–2009

James "Will" Williamson is as impressive on his mountain bike as he is behind the controls of a helicopter. He lives in Texas and comes to my ranch often to ride with me. Recently, he and I were out on the trails and I asked aloud why he had left his family so early on a Sunday morning to come ride. "I'm dealing with stuff," he said, "and this helps."

Will has dealt with a lot of "stuff" as a combat chopper pilot. He has seen too many friends die. While he was on a mission in Iraq in 2005, a bullet came through the cockpit and hit his face shield. The force of the impact knocked him out. Thankfully, his copilot was able to land their bird.

After twenty years of service, Will left the military and now flies for Bell Helicopter as one of their top pilots. However, his transition was not without its challenges. The invisible wounds of war were real for Will. "I was angry, hypersensitive, and torn apart inside," he says. "I had all the symptoms of PTS, and it took me a long time to properly deal with them."

He took up mountain biking seriously, conquering the famous Leadville Trail 100 in the Rocky Mountains and completing a brutal endurance ride in Chile. Along the way, he talked to fellow vets about the "stuff." And it helped him a lot.

As with most veterans, the war lingers in his mind. But Will is doing just fine. He has a meaningful and successful career; a wonderful wife, Jen, who is also a combat veteran; and three lovely kids. (Their oldest, Maximus Chachere, is named for the copilot who saved Will's life.) And he works with other vets to help them come to terms with the "stuff."

Last year, Will led a team of veterans in building a new bike trail on the ranch. I named the trail Dark Horse 21—Will's call sign in the Army—and it's one of my favorites to ride.

JOHN PAUL SZCZEPANOWSKI

UNITED STATES MARINE CORPS, 1989–2014

Born in 1969 at Offutt Air Force Base in Nebraska, John Szczepanowski comes from a legacy of Marines. "It was just in my blood," he says. "It was meant to be." John joined right out of college and was deployed to the Middle East during the first Gulf War.

From 2005 to 2008, John served as a senior noncommissioned officer at Walter Reed. There, John—an accomplished triathlete—built a relationship with a nonprofit called World TEAM Sports and developed a program to help injured Marines recover through cycling. I wonder if John ever imagined he'd one day be on the receiving end of such treatments as he worked to help wounded service members heal.

One year later, in 2009, John was sent to Iraq. That May, he was "blown up," as he puts it. "I was hit by a handheld rocket grenade that went off right over our head, severely injuring our gunner but kind of just ringing my bell a bit." Out of concern for his gunner's life, John ignored his own concussion and got his teammate on a medevac out. John continued on his mission, completed his deployment, and later embarked on another tour—this time to Afghanistan—without ever being treated for TBI. That's when the symptoms from his injuries caught up to him.

Having helped others deal with their problems gave John an advantage in addressing his own. "I found that after I retired my soul felt empty, and I needed to fill it with something positive." John decided to book a trip to South America, where he hiked the Inca Trail toward the abandoned city of Machu Picchu. At one point in the journey, he came across an orphanage for children rescued from human trafficking, a discovery that turned his trip into a more lasting commitment. "Working with these wonderful children, helping them smile again, I felt a spark, a new light. Now I'm learning to forgive myself and allow myself grace so I can move on with my life."

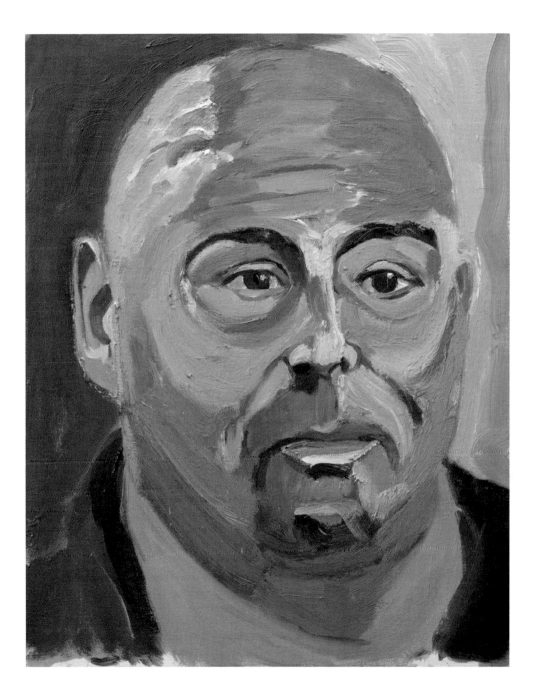

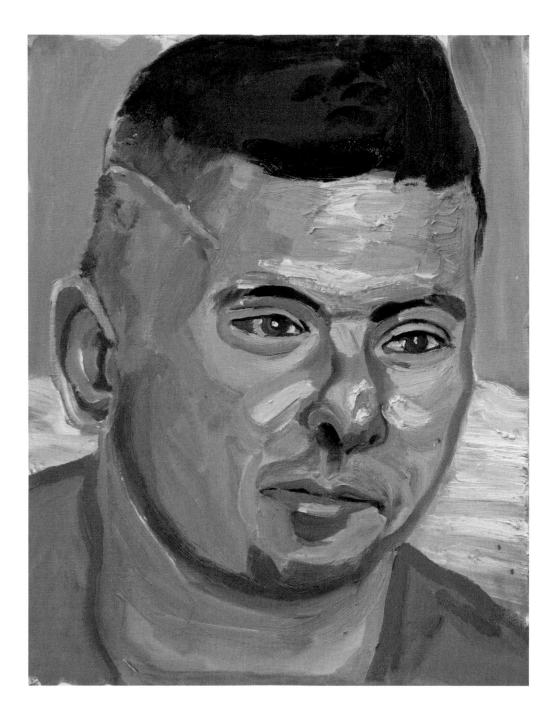

RAMON PADILLA

During a therapy session at Walter Reed, Jim Estes—a professional golfer who founded the Salute Military Golf Association (SMGA)—approached Ramon Padilla.

"I can teach you how to play golf with one hand," Estes offered.

"You're crazy," Ramon said. "Teach me how to catch a baseball or something else. I'm not interested in playing golf."

Ramon moved to the United States from Mexico when he was two years old. He grew up in California, where he worked for a local parks and recreation department and volunteered for the police department after high school. At the age of twenty-five, Ramon joined the United States Army. "I wanted to give back to the country that had given me freedom and opportunity," he says.

He deployed to Iraq in 2005 and Afghanistan in 2007, where his base came under attack. Shrapnel from an RPG severed Ramon's left arm. A round struck the right side of his head, fracturing his skull and leaving him with a TBI and PTS.

Ramon's therapist knew that golf could help with both his visible and his invisible injuries. To encourage Ramon to accept Estes's help, he offered Ramon a few days off from the grueling physical therapy to learn how to play. Suddenly golf became a lot more interesting. And when Ramon hit a shot 150 yards on his first try, he was all in.

"I actually helped design my prosthesis to play golf," Ramon says, "so I really got involved. Just being out there letting it all out, taking my anger out on a little white ball, and having a great time out in the open with grass, trees, birds, rain, sometimes snow—it really benefited me and my family." He got so much out of it, he joined the board of SMGA to help share the game with other wounded vets. Ramon, who was raised just a few miles from Hollywood, reminds them, "There's more than one *American Sniper, Act of Valor,* and *Lone Survivor.* There are thousands of our stories."

CHIEF WARRANT OFFICER THREE
JEREMY JAMES VALDEZ

UNITED STATES ARMY, 1998-PRESENT

I was just sitting down to eat lunch after a long mountain bike ride when Jeremy Valdez and his fiancée wandered over to my table with an unusual request. "Mr. President, will you please sign my tattoo?" Jeremy asked.

"What in the heck for?" I asked.

"Just sign it," Jeremy said. I grabbed a Sharpie and compliantly added my name to the ink already on Jeremy's forearm. Later that night, I was told that Jeremy drove straight to a tattoo parlor and had my autograph permanently emblazoned on top of his Special Forces unit insignia.

After nearly two decades in the military, Jeremy had grown close to the men he served with. His tattoo reminded him of them—particularly those who were with Jeremy in 2009 when his helicopter went down and burst into flames. Even though Jeremy was hurt, he pulled five of his team members from the burning helicopter, saving their lives. Jeremy recovered from his injuries in the hospital, but his serious physical wounds were compounded by headaches, losses in memory and cognitive function, and the haunting images of the ten soldiers he couldn't rescue from the flames.

Jeremy received mental health treatment from the VA and support from a longtime friend named Michael "Rod" Rodriguez (whose portrait is featured on page 128). Rod helped Jeremy understand that his problems weren't unique. In talking to other veterans about his invisible wounds, Jeremy was able to move past them. "I began getting help and continued my education and career, culminating in my master's in diplomacy," he says.

Jeremy's final deployment to Afghanistan in 2012 went a lot better than some of the previous tours. In perhaps the unlikeliest of places, he fell in love with an Army Airborne trauma nurse, Rachel. They were married on June 20, 2015. I couldn't attend the wedding, but I was there in spirit—and with them at the altar, in black ink on Jeremy's arm.

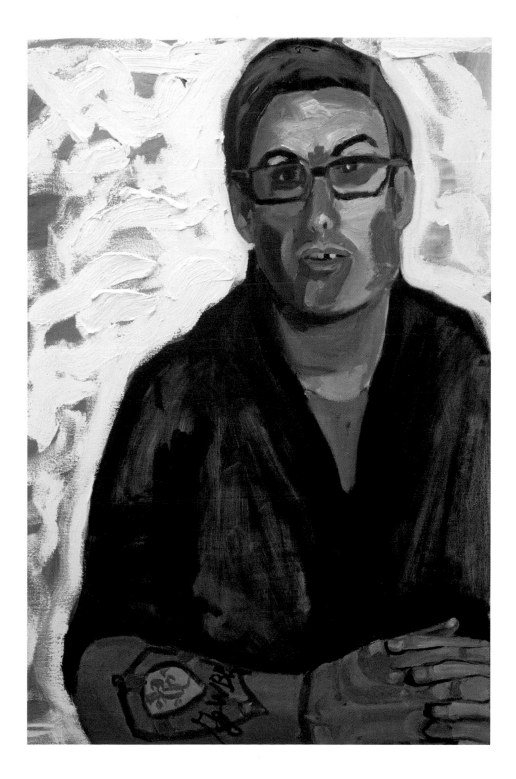

BRYON VINCENT

UNITED STATES ARMY, 2005-2008

Bryon Vincent has a really strong résumé. He graduated from high school in Humble, Texas—a mark in the plus column right off the bat—and attended college at the United States Military Academy, where he played on the golf team. After graduating in 2005, he married Abigail, a West Point classmate. He was commissioned in the Army and quickly rose through the ranks to captain, earning multiple commendations, decorations, awards, and certifications along the way before earning his master's in leadership from Georgetown University.

During Bryon's deployment to Iraq in 2005 and 2006, he was injured in two IED attacks three months apart, leading to his medical retirement in 2008. "At first," Bryon says, "I didn't realize the extent of my injuries. It was just kind of different. I started having memory loss, and it almost seemed comical at first." There was nothing funny about it. "I couldn't slow my brain activity down from what was required to lead counterinsurgency operations and navigate emergency situations. I frequently feel the hypervigilance that was beneficial for survival in 'no-fail' environments, and that results in unnecessary pressure in civilian activities."

When asked what helped most during his recovery, Bryon delivered a clear message. "This is important: it is critical to surround our returning service members with love." In particular, Bryon was thinking about the love of Abigail, an Army major who works at Fort Belvoir Community Hospital. "My wife was absolutely amazing. She stayed emotionally consistent and helped me readjust into a normal routine."

Bryon's normal routine included his lifelong hobby of golf. And it also came to include work, where he learned to use his struggles "as a positive, focusing that extra energy into enhanced performance." Bryon recently started working for the FBI. "My organization works hard to protect the American people," he says. I am confident Bryon will contribute greatly to that mission.

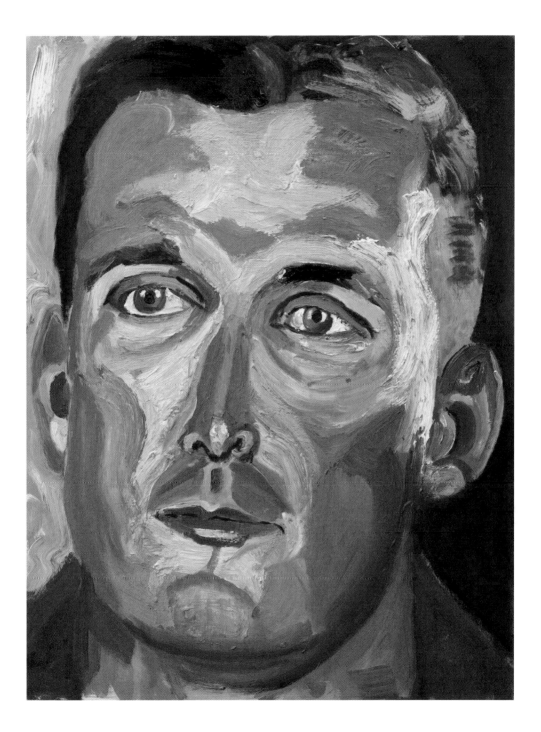

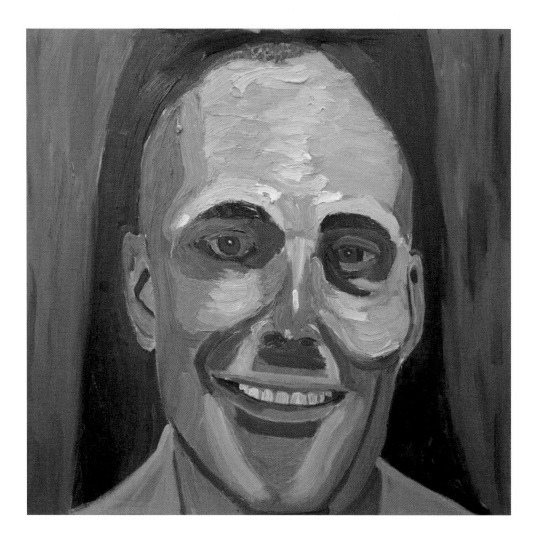

CHRISTOPHER ANDREW TURNER

Chris Turner was sitting next to me at our Warrior Open dinner. I could tell he was a little nervous to stand up and tell his story to the three hundred people there. He had replayed the events in his head hundreds of times, but he had never shared his experience in public.

Chris attended Clemson University on an ROTC scholarship and was commissioned in the Army after he graduated in 2005. He deployed to Iraq in 2007 and then to Afghanistan in 2013, where his story took a dramatic turn. While walking with his commanding officer and another soldier, Chris's group noticed an Afghan security guard—a friendly who was helping guard the base—coming toward them. "We thought he needed our help, because he was running pretty frantically," Chris says. But as the guard got closer, something didn't feel right to Chris. "When he got about fifteen to twenty feet in front of me, we motioned for him to stop. He got very close to us, raised his AK-47 at my chest, and pulled the trigger." The gun misfired, but the Afghan guard soon had his rifle working again. "My fellow soldiers and I exchanged gunfire with him," Chris remembers, "but he was wearing body armor and a helmet, so our pistols were ineffective against his AK-47. Long story short, after a brief firefight, a Romanian soldier in a guard tower shot and killed the guard with his Dragunov sniper rifle. It wasn't until after the firefight that I noticed I had been shot in the thigh."

The wound on Chris's leg healed quickly. But something was wrong. He couldn't sleep, he was anxious. "I realized that I needed to talk to somebody," he says. Chris was diagnosed with PTS. "I often ruminate on what-ifs and play out different scenarios and outcomes with the event," he says. Chris's anxiety began to affect other parts of his life, including his family. And his anguish, which was apparent to me when I met him, affected my first painting of Chris—which takes up the left side of this page.

Fortunately, Chris has a rock in his wife, Katrina. And in their three children, Chris found "inspiration and motivation to be a better person and father." He used golf and fitness to reduce his stress and increase his well-being. He studied post-traumatic stress and learned a lot about how to cope with it. And after working with a therapist, Chris says, "I have accepted the fact that this will always be a part of who I am. It's up to me to make it a positive part of my life."

Chris sent me a letter a few weeks after sharing his story at the Bush Center. Speaking at the event had been "a daunting task," Chris wrote. "However, it took a huge weight off my shoulders and was actually a relief once I finished." He explained that just prior to coming to Dallas, his leaders at Air Command and Staff College had asked him to speak during resiliency training. "I was hesitant and did not feel comfortable sharing my story. As soon as I got back to school after the Warrior Open, I excitedly accepted their invitation with the hope that sharing my struggles and triumphs will help remove the stigma of PTS. I now have the ability to openly communicate with peers without fear or stigma." After reading Chris's letter and learning how well he's doing, I repainted him. His new portrait, on the opposite page, is the same face, the same person—but with a new outlook and a bright future.

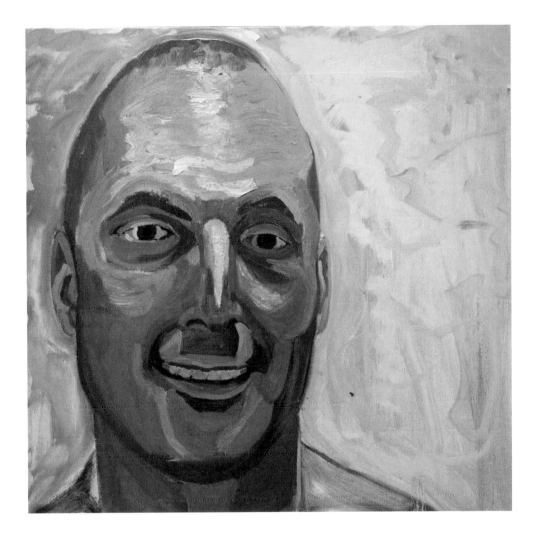

"Veterans need to know that there is always
someone who cares for them, no matter
how bad things get."

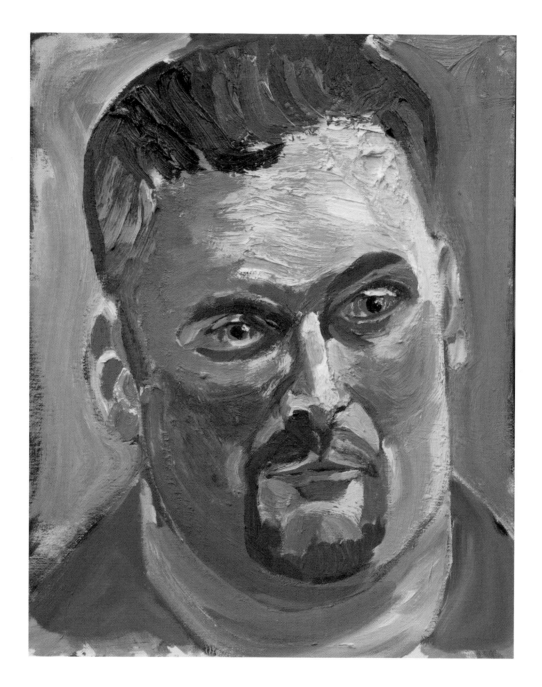

DAVID A. WRIGHT

UNITED STATES MARINE CORPS, 2000–2004

"Growing up, I was always in the trees, jumping out of them, in the mud—exploring," Dave Wright says about his childhood. "So my parents weren't surprised when I joined the Marine Corps later in life. I walked into the recruiting office, and of course every branch pulled me in to talk about their softball leagues and whatnot. But I thought, 'If I'm going to do this, I'm going to do this all the way.' So I joined the Marines."

During his four years in the service, David deployed three times. The third was to Iraq in 2003, at the start of the war. "My battalion, the Thundering Third, was the tip of the spear for the invasion because we were the saltiest Marines out there," David says. As an infantry Marine, he was on the very front lines, "going on patrols, kicking doors in, going house to house."

The combat took a toll on David's body. And after he left the Marines, Dave started to notice that his mind had taken as big of a beating as his body. On Christmas Day 2004, he ate dinner by himself in the basement while his family was upstairs. He didn't know why, and neither did they. A few days later, he had a massive panic attack. "That was the kickoff to what PTSD did to me for the next ten years," he says. He started drinking, the only way he knew to cope with the symptoms. "You're never really taught to ask for help as a Marine. You don't want to show those signs of weakness." He managed to earn his bachelor's degree, but after abusing alcohol to hide from his problems and sleep at night, he lost control. "I woke up in a hospital with a feeding tube in my nose," Dave remembers. Thankfully, his family had intervened in time and saved his life.

Dave gave up drinking two years ago and is now in the process of fulfilling a lifelong dream by opening his own business. "I'm excited for the future," he says. "Now I'm in control of my own destiny."

MATTHEW ZBIEC

Being a Marine comes with a lot of challenges. When Matt Zbiec joined, he discovered a perk: Southern California. After enduring eighteen Chicago winters, Matt arrived for training in 2003 at the Marine Corps Recruit Depot in San Diego. From there, he reported for duty at his new base, Twentynine Palms.

Matt's next move was to Iraq, a dramatic change of scenery from California. On October 10, 2005, Matt was leading an infantry squad in the embattled city of Fallujah when an IED was remotely detonated just eight feet away. Matt describes it succinctly: "It was a significantly large blast, and it really changed my life." He spent two months in the hospital in Bethesda, undergoing surgeries on his hands and legs. He lost some of his fingers and was diagnosed with hearing loss and a TBI.

Matt gives thanks to a group called World TEAM Sports, which helped him get involved with mountain biking and participating in the 2012 W100K in the Palo Duro Canyon. "They're a wonderful organization, helping and empowering these men and women by giving us a physical activity and helping us remember what it's like to feel good," he says. "The fight continues long after we take off the uniform. For those wounded in combat, whether the scars are visible or invisible, the camaraderie really helps. Being with the brothers and sisters we've served alongside is very therapeutic."

Matt's recovery continues to this day. He has learned to cope with the anxiety, anger, and depression—what he calls the "demons" of PTS. Much of the credit goes to his wife, Emilia. "My loving, supportive, and beautiful wife has played a huge role in my recovery," Matt says. "Her unwavering faith in God, and in me, gave her the strength and courage to pull us both through the hardest of times."

Today, Matt and Emilia are raising their three children in Southern California. "My family is everything to me," he says. "We've learned a lot together, and I'm very grateful for all of God's blessings."

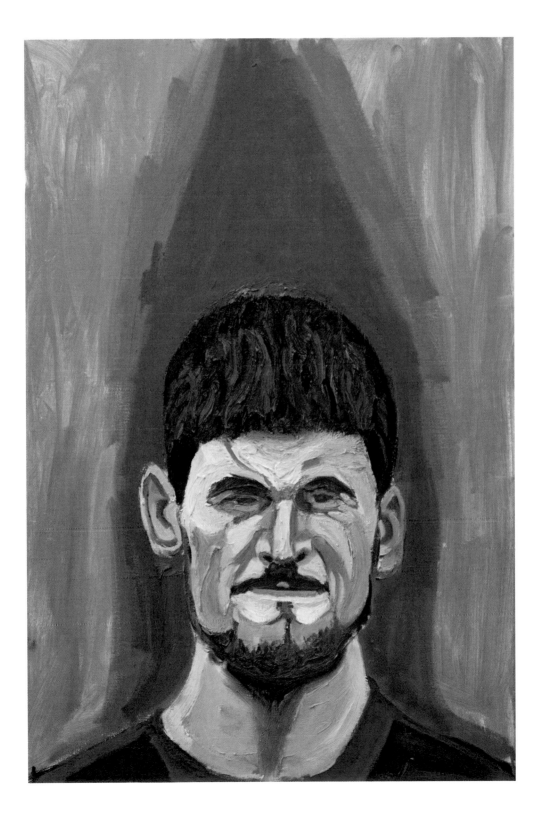

THOMAS BROOKS

Growing up in Tappahannock, Virginia, Thomas "TJ" Brooks played four sports in high school—football, wrestling, baseball, and soccer—and loved to hunt, fish, play golf, and spend time on the water. He is a man in constant motion who doesn't like to sit idle. So when TJ stepped on an IED in Afghanistan's Helmand Province, resulting in the loss of his right leg above the knee and mild TBI and PTS, he didn't waste any time in his recovery. He was walking in six weeks, playing golf in six more, and competing in our Institute's tournament that September. "During my recovery," TJ says, "I did what I did all my life: I pushed myself to find my new normal and stayed as active as I could."

TJ's service in the Marine Corps commenced in June 2006. He completed two tours in Iraq before being deployed to Afghanistan. He took pride in the mission and in the ways he contributed and conducted himself. "I looked after my Marines and always ensured that I had the betterment of my men in mind. I took time to engage with the locals and got to know the kids in the areas I was deployed, and I gained their trust," TJ says, highlighting a critical and often overlooked component of our military's work to liberate and secure Afghanistan and Iraq.

Today, TJ is a full-time student pursuing his degree at Baylor University in Texas. He plans to earn his MBA and eventually start his own outdoors business. "Sure, war has had some change on my life," he says. "But I am still the same person I was before. I still seek to be the best at whatever I am doing. I'm going to work hard and build the life I want."

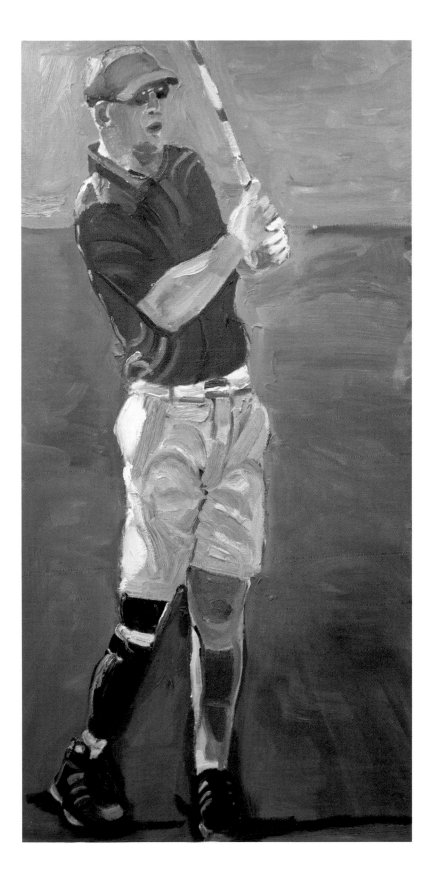

ADAM JAHNKE

UNITED STATES MARINE CORPS, 2005–2010

Adam Jahnke was in the ninth grade when he saw the World Trade Center collapse on television. "Oh, it's a new movie coming out," he thought. When Adam found out we had been attacked by terrorists on 9/11, he made up his mind to join the military. His father served in Vietnam, and Adam often thought about joining the infantry as a young boy.

He was deployed twice to Iraq and injured multiple times, most often by IEDs. He remembers one in particular that knocked him unconscious and gave him a TBI. The symptoms grew worse and worse over time, migraines and memory loss among the most challenging of them. "It seemed like everything I tried from the VA and the numerous pharmaceuticals weren't helping me get better, so I turned to an unhealthy alternative and began drinking heavily," Adam says.

What helped Adam the most was the doctors who took the time to truly understand his case. Rather than putting him into a category and handing him a prescription, he says, "they found alternative treatments that worked best and were tailored to [me]." He also benefited from an organization called the Semper Fi Fund, which got him back into cycling and jump-started his civilian career by helping him with his résumé and conducting mock job interviews. "Now I live on a lovely scenic lake in the mountains of South Carolina, working as a firefighter and spending my time off raising my children with my wife of four years," Adam says.

In reviewing Adam's biography for this project, I was struck by a comment Adam made. He said, "I was proud that President Bush was at the top echelon in charge of me when I was fighting, and that he cared about me." Adam's simple words stayed with me as I painted him. I hope he and his brothers and sisters in arms know that I care about them still, and that I will until the day I die.

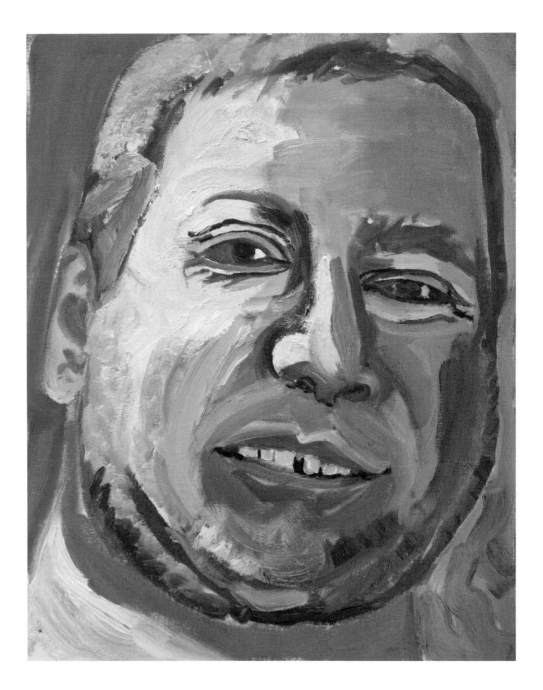

INDEX

SERGEANT FIRST CLASS
SCOTT ALAN ADAMS SR.
U.S. ARMY, 1986–2008
Oil on stretched canvas, 24" X 36"
PAGE 35

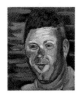

SERGEANT
MATTHEW S. AYERS
U.S. NAVY RESERVE, 2003–2005
U.S. ARMY NATIONAL GUARD, 2005–2010
U.S. ARMY RESERVE, 2010–PRESENT
Oil on stretched canvas, 20" X 24"
PAGE 36

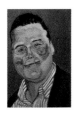

CAPTAIN
JAE BARCLAY
U.S. ARMY, 2004–2008
Oil on stretched canvas, 24" X 36"
PAGE 39

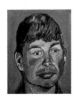

MASTER SERGEANT
SEAN BENNETT
U.S. ARMY, 1992–2010
Oil on stretched canvas, 14" X 18"
PAGE 43

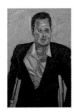

SERGEANT
JUSTIN BOND
U.S. ARMY, 1996–1997 AND 2002–2005
Oil on stretched canvas, 24" X 36"
PAGE 111

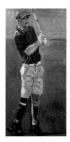

SERGEANT
THOMAS BROOKS
U.S. MARINE CORPS, 2006–2012
Oil on stretched canvas, 24" X 48"
PAGE 172

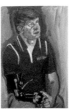

STAFF SERGEANT
TIMOTHY BROWN
U.S. MARINE CORPS, 2003–2014
Oil on stretched canvas, 24" X 36"
PAGE 45

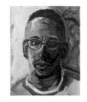

SERGEANT
DANIEL CASARA
U.S. ARMY, 1994–2008
Oil on gesso board, 14" X 18"
PAGE 40

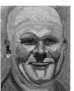

SERGEANT
BRYCE FRANKLIN COLE
U.S. ARMY, 2005–2009
Oil on gesso board, 16" X 20"
PAGE 47

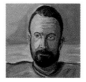

STAFF SERGEANT
ZACHARIAH COLLETT
U.S. ARMY, 2002–2010
Oil on stretched canvas, 30" X 30"
PAGE 48

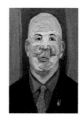

LIEUTENANT COLONEL
JUSTIN CONSTANTINE
U.S. MARINE CORPS, 1997–2013
Oil on stretched canvas, 24" X 36"
PAGE 53

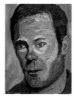

SERGEANT FIRST CLASS
THOMAS WILLIAM COSTELLO
U.S. ARMY, 2002–2014
Oil on stretched canvas, 18" X 24"
PAGE 106

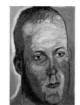

STAFF SERGEANT
BEN DELLINGER
U.S. ARMY, 2003–2009
Oil on stretched canvas, 24" X 36"
PAGE 59

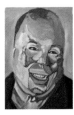

MASTER SERGEANT
ISRAEL DEL TORO JR.
U.S. AIR FORCE, 1997–PRESENT
Oil on stretched canvas, 24" X 36"
PAGE 65

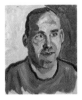

SERGEANT MAJOR
CHRIS DEMARS
MASSACHUSETTS ARMY NATIONAL GUARD,
1988–2015
Oil on gesso board, 16" X 20"
PAGE 62

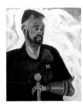

STAFF SERGEANT
MATTHEW DEWITT
U.S. ARMY, 1998–2004
Oil on stretched canvas, 20" X 24"
PAGE 69

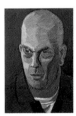

STAFF SERGEANT
ALVIS "TODD" DOMERESE
U.S. ARMY, 1998–2013
Oil on stretched canvas, 24" X 36"
PAGE 114

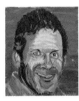

FIRST LIEUTENANT
BRIAN DONARSKI
U.S. MARINE CORPS, 1987–1998
U.S. ARMY, 2004–2012
Oil on stretched canvas, 20" X 24"
PAGE 73

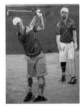

STAFF SERGEANT
ROBERT DOVE
U.S. ARMY, 2008–2014
SERGEANT FIRST CLASS
JOHN FAULKENBERRY
U.S. ARMY, 2001–2012
Oil on stretched canvas, 36" X 48"
PAGE 86

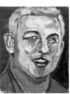

LIEUTENANT COLONEL
KENNETH MICHAEL DWYER
U.S. ARMY, 1998–PRESENT
Oil on gesso board, 16" X 20"
PAGE 74

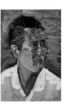

SERGEANT
JAY K. FAIN JR.
U.S. ARMY, 2005–2008
Oil on stretched canvas, 24" X 36"
PAGE 79

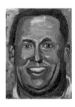

LIEUTENANT COLONEL
DANIEL GADE
U.S. ARMY, 1992–PRESENT
Oil on stretched canvas, 24" X 36"
PAGE 81

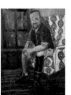

SERGEANT
TIMOTHY GAESTEL
U.S. ARMY, 2001–2005
Oil on gesso board, 12" X 16"
PAGE 84

SERGEANT
WILLIAM J. GANEM
U.S. MARINE CORPS, 1996–2005
Oil on stretched canvas, 36" X 48"
PAGE 137

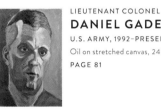

SPECIALIST
ALEXANDER GLENN-CAMDEN
U.S. ARMY, 2010–2012
Oil on stretched canvas, 14" X 18"
PAGE 90

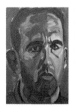

PETTY OFFICER THIRD CLASS
CHRIS GOEHNER
U.S. NAVY, 2003–2006
Oil on stretched canvas, 24" X 36"
PAGE 93

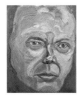

LIEUTENANT COLONEL
DAVID HAINES
U.S. ARMY, 1983–1986 AND 1992–2012
ARMY NATIONAL GUARD, 1986–1991
Oil on gesso board, 18" X 24"
PAGE 94

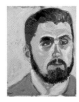

SERGEANT
ANDY HATCHER
U.S. MARINE CORPS, 2002–2006
Oil on gesso board, 14" X 18"
PAGE 105

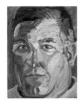

SERGEANT FIRST CLASS
JEREMY D. HENDERSON
U.S. ARMY, 1993–2007
Oil on gesso board, 14" X 18"
PAGE 56

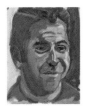

SPECIALIST
JUAN CARLOS HERNANDEZ
U.S. ARMY, 2006–2011
Oil on gesso board, 14" X 18"
PAGE 31

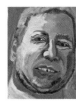

STAFF SERGEANT
ANDREW W. HILLSTROM
U.S. ARMY, 2004–2009
Oil on gesso board, 14" X 18"
PAGE 109

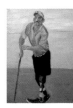

LANCE CORPORAL
ADAM JAHNKE
U.S. MARINE CORPS, 2005–2010
Oil on gesso board, 14" X 18"
PAGE 174

SERGEANT FIRST CLASS
JACQUE KEESLAR
U.S. ARMY, 1990–2011
Oil on stretched canvas, 36" X 48"
PAGE 61

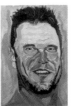

LANCE CORPORAL
TIMOTHY JOHN LANG
U.S. MARINE CORPS, 2005–2010
Oil on stretched canvas, 24" X 36"
PAGE 112

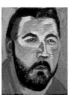

SERGEANT
ROBERT K. LEONARD
U.S. ARMY, 2003–2007
Oil on stretched canvas, 14" X 18"
PAGE 118

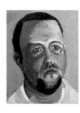

SPECIALIST
JACOB LERNER
U.S. ARMY, 2006–2010
Oil on gesso board, 14" X 18"
PAGE 121

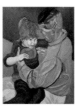

STAFF SERGEANT
SCOTT P. LILLEY
U.S. AIR FORCE, 1999–2010
Oil on gesso board, 36" X 48"
PAGE 28

SERGEANT
SAUL MARTINEZ
U.S. ARMY, 2006–2010
Oil on stretched canvas, 24" X 48"
PAGE 123

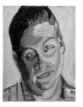

CORPORAL
JOSHUA MICHAEL
U.S. ARMY, 2009–2013
Oil on stretched canvas, 14" X 18"
PAGE 125

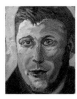

STAFF SERGEANT
SPENCER C. MILO
U.S. ARMY, 2006-2013
Oil on gesso board, 14" X 18"
PAGE 126

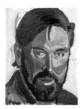

MASTER SERGEANT
SCOTT NEIL
U.S. ARMY, 1986-2010
Oil on stretched canvas, 18" X 24"
PAGE 22

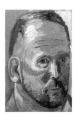

STAFF SERGEANT
DAN NEVINS
U.S. ARMY, 1991-1999
ARMY NATIONAL GUARD, 1999-2006
Oil on stretched canvas, 24" X 36"
PAGE 133

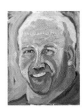

FIRST LIEUTENANT
DENIS OLIVERIO
U.S. MARINE CORPS, 1987-2007
Oil on gesso board, 14" X 18"
PAGE 134

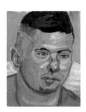

SERGEANT FIRST CLASS
RAMON PADILLA
U.S. ARMY, 2000-2009
Oil on gesso board, 14" X 16"
PAGE 159

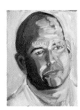

SERGEANT
MICHAEL JOSEPH
LEONARD POLITOWICZ
U.S. MARINE CORPS, 2010-PRESENT
Oil on stretched canvas, 18" X 24"
PAGE 99

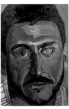

SERGEANT FIRST CLASS
MICHAEL R. RODRIGUEZ
U.S. ARMY, 1992-2013
Oil on stretched canvas, 24" X 36"
PAGE 129

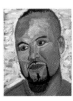

STAFF SERGEANT
OMAR ROMNEY
U.S. ARMY, 1999-2004
Oil on stretched canvas, 14" X 18"
PAGE 142

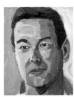

CAPTAIN
KEVIN L. ROSENBLUM
U.S. ARMY, 2004-2009
Oil on gesso board, 16" X 20"
PAGE 70

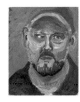

SPECIALIST
LEE SAGE
U.S. NAVY, 2002-2006
U.S. ARMY, 2010-2013
Oil on gesso board, 16" X 20"
PAGE 145

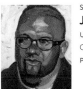

SPECIALIST
JOSÉ E. SANTIAGO
U.S. ARMY, 1999-2006
Oil on gesso board, 14" X 16"
PAGE 146

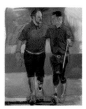

STAFF SERGEANT
JACK SCHUMACHER
U.S. ARMY, 2005-2011
Oil on stretched canvas, 48" X 60"
PAGE 139

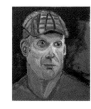

SERGEANT MAJOR
CHRISTOPHER SELF
U.S. ARMY RESERVE, 1984-1986
U.S. ARMY, 1986-2013
Oil on stretched canvas, 20" X 24"
PAGE 19

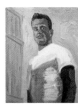

CORPORAL
DAVID SMITH
U.S. MARINE CORPS, 2003–2007
Oil on stretched canvas, 24" X 36"
PAGE 101

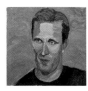

LIEUTENANT COLONEL
KENT GRAHAM SOLHEIM
U.S. ARMY, 1994–PRESENT
Oil on stretched canvas, 30" X 30"
PAGE 50

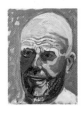

STAFF SERGEANT
JAMES M. STANEK JR.
U.S. ARMY, 2003–2008
Oil on stretched canvas, 18" X 24"
PAGE 148

FIRST LIEUTENANT
MELISSA STOCKWELL
U.S. ARMY, 2002–2005
Oil on stretched canvas, 36" X 48"
PAGE 151

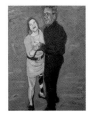

GUNNERY SERGEANT
JOHN PAUL SZCZEPANOWSKI
U.S. MARINE CORPS, 1989–2014
Oil on gesso board, 14" X 16"
PAGE 156

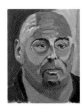

MAJOR
CHRISTOPHER ANDREW TURNER
U.S. ARMY, 2005–PRESENT
Oil on stretched canvas, 30" X 30"
PAGE 165

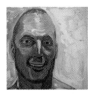

MASTER SERGEANT
ROQUE URENA
U.S. AIR FORCE, 1983–2008
Oil on stretched canvas, 36" X 24"
PAGE 25

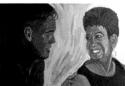

CHIEF WARRANT OFFICER THREE
JEREMY JAMES VALDEZ
U.S. ARMY, 1998–PRESENT
Oil on stretched canvas, 24" X 36"
PAGE 160

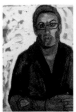

CAPTAIN
BRYON VINCENT
U.S. ARMY, 2005–2008
Oil on gesso board, 18" X 24"
PAGE 162

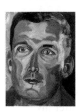

CHIEF WARRANT OFFICER THREE
JAMES WILLIAMSON
U.S. AIR FORCE, 1989–1999
U.S. ARMY, 1999–2009
Oil on stretched canvas, 18" X 24"
PAGE 155

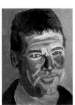

SERGEANT
DAVID A. WRIGHT
U.S. MARINE CORPS, 2000–2004
Oil on gesso board, 14" X 16"
PAGE 169

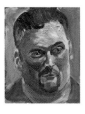

SERGEANT
MATTHEW ZBIEC
U.S. MARINE CORPS, 2003–2007
Oil on stretched canvas, 24" X 36"
PAGE 170

SERGEANT
LESLIE ZIMMERMAN
U.S. ARMY, 2001–2004
Oil on stretched canvas, 20" X 24"
PAGE 26

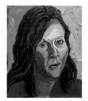

THE MEN AND WOMEN IN THE MURAL AND THEIR STORIES

CAPTAIN
MATT ANDERSON
U.S. ARMY, 2005–2014
Oil on stretched canvas, 36" X 48"

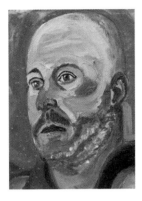

Matt Anderson was in college on September 11, 2001. After the attacks, he heard a call to serve his country, and he answered it by joining the Army. In 2010, Matt was awarded the Purple Heart after his right foot and lower leg were shattered by a land mine while clearing a Taliban-controlled compound in Afghanistan. While stationed at Fort Carson, he helped to establish a golf clinic for wounded warriors. Matt recently returned to school to become a physician's assistant.

STAFF SERGEANT
ANDREW BACHELDER
U.S. MARINE CORPS, 2002–2011
Oil on stretched canvas, 48" X 60"

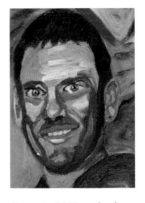

While serving in Afghanistan in 2009, Andrew Bachelder was seriously injured in a midair helicopter collision, resulting in a broken pelvis, hip, back, right shoulder, and right tibia and fibula. He struggled with TBI and PTS when he returned home. He credits his wife, Debi, with nursing him back to life—and saving him from taking his own. Andrew won the Warrior Open in 2015 and subsequently played a round with Masters and U.S. Open champion Jordan Spieth. I have a special bond with Andrew and Debi's thoughtful children, Kaitlin and Jake, who bring me Jolly Ranchers when I see them

STAFF SERGEANT
NICHOLAS BRADLEY
U.S. AIR FORCE, 2002–2009
Oil on stretched canvas, 36" X 48"

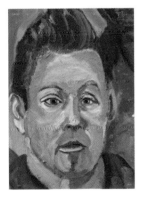

In 2008, Nick Bradley's vehicle was struck by an IED in Afghanistan, crushing every bone in his face, along with his right arm, right hand, right hip, right shin, and right foot. He lost several fingers and had 16 surgeries and facial reconstructions. When he was told he wouldn't walk again, he taped a picture of his daughter next to his bed and used her as motivation to fully recover. Nick earned his degree in political science at the University of North Texas, and married Lindsay, whom he met at the Warrior Open. I recently had the privilege of walking out to the mound with him when he threw out the first pitch at a Texas Rangers game.

STAFF SERGEANT
JOSHUA CHINN
U.S. ARMY, 2003–2011
Oil on stretched canvas, 36" X 48"

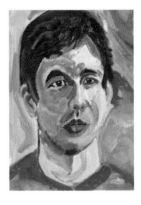

In 2012, I received an invitation to Joshua Chinn's wedding. I couldn't make it, so I called him to offer my congratulations—and invited him to ride in the W100K. Watching him ride, one wouldn't realize that he had undergone more than 50 surgeries after an IED in Iraq severed his left Achilles tendon, two arteries, and his left sciatic nerve; fractured his hip, femur, and ribs; gave him a TBI; and left more than one hundred pieces of shrapnel lodged in his legs. He lives in Denver with his wife, Jen, and their two children, where Joshua works for the VA.

MANNY COLÓN
U.S. ARMY, 1993–2013

Oil on stretched canvas, 48" X 60"

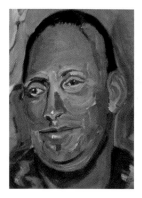

During a 2004–2005 deployment to Afghanistan, Manny Colón sustained head trauma from enemy rocket fire, resulting in PTS and TBI. Upon his return home, he was diagnosed with a Stage IV non-Hodgkin's follicular lymphoma. As part of his recovery, he learned to mountain bike. After the first ride, he joked, "I got the record for who fell the most." Manny completed his 20-year career with the Army and lives in Florida with his wife and two children.

LIEUTENANT COLONEL
JUSTIN CONSTANTINE
U.S. MARINE CORPS, 1997–2013

Oil on stretched canvas, 36" X 48"

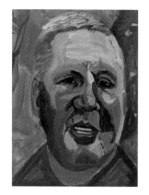

[See page 53 for profile]

MAJOR
CHRISTOPHER CORDOVA
U.S. ARMY, 1996–PRESENT

Oil on stretched canvas, 48" X 60"

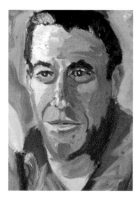

Chris Cordova was one of just 53 soldiers at Combat Outpost Keating in Afghanistan in 2009 when approximately 400 Taliban fighters attacked their base. Chris survived the onslaught but suffered TBI from multiple IED explosions. He was the senior medical officer, performing life-saving operations during the raid. Chris rides his mountain bike to relieve stress and control his emotions. He recently earned his Doctorate from Baylor University and left the States for another deployment.

MASTER SERGEANT
CHRISTIAN COTE
U.S. MARINE CORPS, 1989–1992

U.S. ARMY NATIONAL GUARD, 1994–PRESENT

Oil on stretched canvas, 48" X 60"

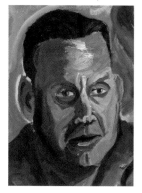

Ever since his vehicle was hit by an IED in Afghanistan in 2011, Chris Cote has dealt with invisible wounds including TBI, post traumatic vision syndrome, and balance and speech issues. His family and his fellow vets have helped him overcome his injuries with their unconditional love and their undying support. "You realize you aren't alone," he says. Chris continues his military service and in his free time is discovering the joys of being a grandfather.

CORPORAL
ERIC ELROD
U.S. MARINE CORPS, 2001–2005

Oil on stretched canvas, 36" X 48"

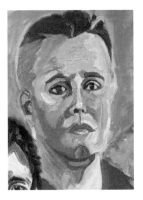

During a patrol in Fallujah on his second deployment to Iraq, Eric Elrod was ambushed. He sustained gunshot wounds to his femur, which eventually had to be replaced with a titanium rod, severely limiting his mobility. Nevertheless, Eric took up mountain biking and running in 2009. He has since completed the Wounded Warrior Half Marathon (twice), several adventure races, and the Cowtown Half Marathon in Fort Worth, where he lives with his family and works for Hillwood Development Company.

FIRST SERGEANT
ROBERT FERRARA
U.S. ARMY, 1989–2012

Oil on stretched canvas, 48" X 60"

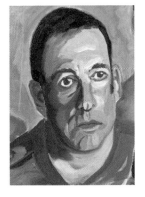

Rob Ferrara sustained a shoulder injury, a TBI, and PTS when a roadside bomb detonated near him in Iraq in 2007. Rob recognizes that his recovery will probably be a lifelong effort. After I showed him his painting when he came to ride with me on my 70th birthday, he told me that I captured the pain he was living with—and that he is now happy again and full of love. Rob and his family live in San Antonio, where Rob works to help other wounded warriors heal through mountain biking.

COMMAND SERGEANT MAJOR
BRIAN FLOM
U.S. ARMY, 1991–PRESENT

Oil on stretched canvas, 48" X 60"

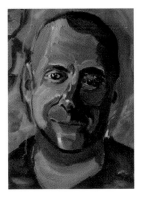

Brian Flom joined the U.S. Army in August 1991 as a military policeman and has been on active duty ever since. In October 2007, he was wounded during a rocket attack in Baghdad, leaving him with PTS and a TBI. Brian continued serving and was recently selected to serve as Brigade Command Sergeant Major at Joint Base Lewis-McChord in Washington State, where he takes a special interest in helping his fellow wounded warriors recover through outdoor activities—what he calls his "therapy and pharmacy."

MAJOR
JOHN D. GREER
U.S. NAVY, 1975–1979; U.S. ARMY, 1986–2003

Oil on stretched canvas, 48" X 60"

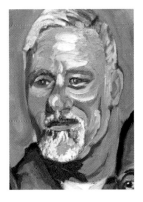

JD Greer served his country on active duty for 21 years in the United States military before retiring as a major in 2003. Three years later, JD was in Iraq, serving on a security detail for my ambassador to the country, Zalmay Khalilzad. He was behind the wheel of his vehicle when five EFPs blew up, instantly taking off JD's right arm below the elbow. During his recovery at Walter Reed, JD got involved in scuba diving and mountain biking—activities he has since helped other wounded warriors use to heal.

JOSH HANSEN

U.S. ARMY, 2001–2010

Oil on stretched canvas, 48" X 60"

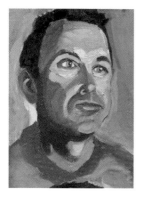

At age 30, Josh Hansen left his comfortable life as a small business owner to serve his country in the aftermath of 9/11. During his second deployment to Iraq, Josh was responsible for IED removal. His vehicle was struck by explosives in eight separate incidents, leading to PTS, TBI, hearing loss, and neck and back injuries. Having conquered his own battle with invisible wounds, Josh partnered with his wife, Melissa, to found a nonprofit called Continue Mission, which helps to improve mental health and prevent suicide among veterans.

CHIEF WARRANT OFFICER FIVE
JIM HERRING

U.S. ARMY, 1980–1983; U.S. ARMY RESERVE, 1985–1994
ARMY NATIONAL GUARD, 1994–PRESENT

Oil on stretched canvas, 48" X 60"

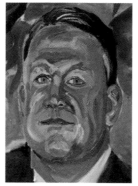

Jim Herring has worn the uniform of the United States since 1980. Even after leaving active duty and serving his community in law enforcement, Jim stayed on with the Reserve and then National Guard, where he continues to serve to this day, despite having been injured in an IED attack in 2007. Jim recently completed his bachelor's degree in business administration.

STAFF SERGEANT
JOSHUA KRUEGER

U.S. MARINE CORPS, 1997–2006

Oil on stretched canvas, 48" X 60"

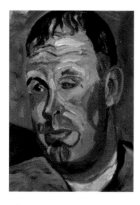

I learned about Josh Krueger from his friend Christopher Howard, whose father, George, died at the World Trade Center, and whose police shield I carried throughout the Presidency and is on display in the Museum at the Bush Center. I learned from Chris that Josh was a Marine who lost his left eye after surviving an IED blast in Iraq in 2006. Having used physical activities like Brazilian jujitsu and mountain biking in his recovery, Josh uses his example and his experiences to encourage other wounded warriors that their lives need not be limited by their injuries.

FIRST SERGEANT
PETER LARA

U.S. ARMY, 1992–2011

Oil on stretched canvas, 48" X 60"

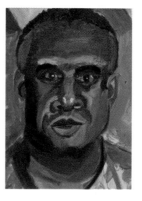

In 2005, Pete Lara's unit was on the hunt for Abu Musab al-Zarqawi, the leader of Al Qaeda in Iraq. When they raided his suspected safe-house, they were ambushed. Pete was surrounded and took enemy fire from all directions. The first bullet went through Pete's weapon and hit him in the face; then he was shot from the left through his arm and back, and again from the right. After 50 surgeries and a lot of hard work, Pete plays a solid game of golf.

LANCE CORPORAL
ADAM MCCANN
U.S. MARINE CORPS, 2004–2006
Oil on stretched canvas, 48" X 60"

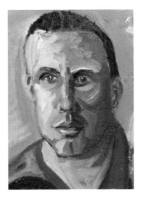

Adam McCann was injured in Iraq in 2005 by shrapnel from mortar explosions. Tendons and muscles in his legs were severed, severely limiting Adam's mobility. When he returned home, the pain, TBI, and PTS led Adam to lose interest in his previous passions, his family, and his friends. Eventually, mountain biking helped Adam start to recover. In 2014, he completed what is widely regarded as the most challenging mountain bike race in the world, the Leadville Trail 100 in Colorado.

STAFF SERGEANT
CHRISTOPHER MCCOY
U.S. ARMY, 2003–2011
Oil on stretched canvas, 48" X 60"

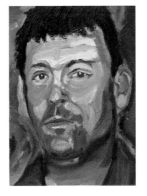

In Iraq, Chris McCoy was responsible for guarding a dangerous stretch of road between Fallujah and Ramadi. Over the course of his tour, he was injured in six separate IED explosions. As a combat medic, he received the Army Commendation Medal for performing lifesaving procedures on nine people in a single day. Chris has used golf as one way to help deal with his severe TBI and PTS migraines. He and his wife, Anna, recently became first-time parents.

STAFF SERGEANT
ANDREW MONTGOMERY
U.S. ARMY, 2004–2013
Oil on stretched canvas, 36" X 48"

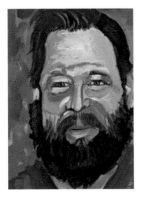

Andrew Montgomery signed up for the Army at age 17. While serving as a squad leader on a patrol in Afghanistan, Andrew stepped on an IED, damaging his right shoulder, left knee, and spinal cord, and giving him a TBI. After struggling through months of speech and physical therapy, Andrew says it was his wife who motivated him to "get off [his] butt and do things." Today, he is a PGA Professional and helps others benefit from golf as a form of therapy.

STAFF SERGEANT
MIKE MORABITO
U.S. ARMY, 2003–2008
Oil on stretched canvas, 48" X 60"

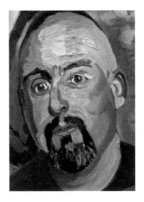

Before Mike Morabito joined the Army, he played minor league baseball. During a deployment in 2004, a uniformed Iraqi police officer detonated his vehicle next to Mike's truck, leaving Mike with severe burns to his hands and face, spinal and knee injuries, and PTS and TBI. Mike confronted his invisible injuries with a holistic approach, and today he encourages his fellow wounded warriors to waste no time finding the type of therapy that works best for them.

SAM MORTIMER

U.S. MARINE CORPS, 1995–2015

Oil on stretched canvas, 48" X 60"

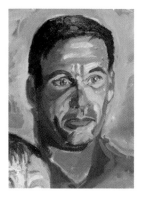

Sam Mortimer served in the Marine Corps for 20 years. He deployed to Iraq and Afghanistan. After returning stateside, Sam found that getting "back to normal" wasn't easy, especially knowing that some of his men were still in harm's way. Support from his family and a number of nonprofit military organizations helped Sam adjust to his new civilian life and cope with PTS. Sam rides his bike to blow off steam and keeps extra bikes in his garage to help other veterans leave their struggles behind them.

DEWITT OSBORNE

U.S. ARMY, 1982–1990 AND 2005–2010

Oil on stretched canvas, 48" X 60"

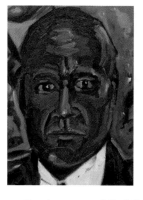

DeWitt Osborne served in the Army for nine years before leaving to go to college. After 9/11, his younger brother was deployed to Afghanistan, and DeWitt was inspired to continue his service. He reenlisted at age 42 and deployed to Iraq with the 101st Airborne. In 2006, DeWitt was injured by an IED blast. He spent four years at Walter Reed. DeWitt credits the grace of God for keeping him alive after 21 surgeries and helping him recover from the psychological horrors of war. No doubt that helped a lot, but I also give credit to DeWitt's courage and resilience.

WILLIAM PAUL

U.S. ARMY, 1990–2012

Oil on stretched canvas, 36" X 48"

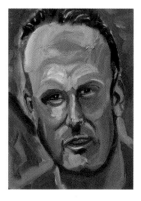

Billy Paul has served as a jumpmaster instructor with the 82nd Airborne, an infantry evaluator, and an honor graduate of the U.S. Army Sniper School during his 22-year career. In 2003, he was struck by an IED in Iraq, causing nerve damage throughout his upper body and leaving Billy with PTS and TBI. His wife, Donna—whom he married 11 days after meeting her, 22 years ago—was an anchor for their family during Billy's recovery. Their two oldest sons recently followed in their father's footsteps and joined the Army; their daughter graduates from high school this year.

CHAD PFEIFER

U.S. ARMY, 2005–2008

Oil on stretched canvas, 48" X 60"

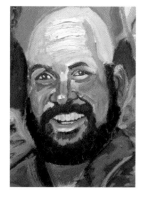

Chad Pfeifer lost his leg above the knee in 2007 when his truck hit a pressure-plate IED in Iraq. After hard work and with help from his wife, Summer, Chad picked up the game of golf, a sport in which he excels. Chad won the Warrior Open three times. One of my favorite trips was with Chad to the 2013 Presidents Cup at Muirfield Village in Ohio. I was thrilled to introduce him to golf greats like Jack Nicklaus, Tiger Woods, and Jordan Spieth—all of whom were honored to meet Chad. Chad recently competed in "The Big Break" on the Golf Channel.

JOHN REGO
U.S. ARMY, 2001–2005

Oil on stretched canvas, 48" X 60"

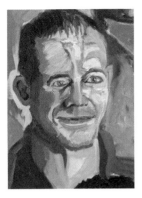

In April 2003, right after the liberation of Iraq, John Rego's team was clearing a weapons cache when an artillery round collapsed the building he was in. He was buried in rubble, and his body and internal organs were crushed. After John recovered at Walter Reed, he says he noticed a decline in his mental state. A veterans service organization encouraged John to focus on his wellness, and it worked. Today John encourages other wounded warriors to work on two things as soon as they transition out of the service: finding meaningful employment and exercising regularly.

STAFF SERGEANT
JASON ROBERTS
U.S. MARINE CORPS, 2000–2011

Oil on stretched canvas, 36" X 48"

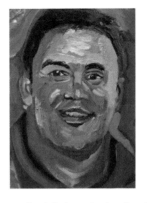

Jason Roberts grew up as what he calls a "military brat" in a family with a tradition of service. After joining the Marines in 2001, Jason was manning the turret in Afghanistan in 2009 when an IED detonated and threw him from his vehicle. His pelvis, back, and ribs were injured, and his left leg had to be amputated below the knee. Jason grew tired of being in a wheelchair and what he describes as the sterile hospital environment. So he golfed. He thanks veterans organizations for helping to accelerate his recovery and his wife, Christina, for sticking by him.

TECHNICAL SERGEANT
DAVID ROMANOWSKY
U.S. AIR FORCE, 1994–2011

Oil on stretched canvas, 36" X 48"

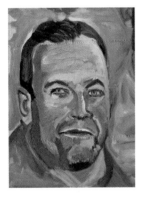

Dave Romanowsky is a Dallas-area transplant, so I call him Romo as a nod to our home team's quarterback. (I'm not sure whether Dave, a Steelers fan, appreciates that nickname.) Dave was injured by an IED in Iraq toward the end of his 16-year career with the United States Air Force. Dave attributes his recovery to the fact that he didn't want his wife, Gayla, or their children to see him as a broken man. Golf has helped Dave regain his strength and flexibility and an optimistic outlook on his future.

SERGEANT
MICHAEL STAFFORD
ARMY NATIONAL GUARD, 1993–2000 AND 2004–2006

Oil on stretched canvas, 36" X 48"

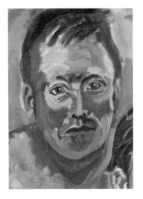

Mike Stafford is a positive man who believes in the power of prayer. So when he lost his left leg below the knee from an IED explosion in Iraq in 2005, he didn't complain about his injury; instead, he chose to see the upside. Having grown up on a golf course in Tupelo, Mississippi, Mike says that playing with a missing leg has forced him to work on his balance and focus on his swing. As a result, he hits the golf ball even better than ever before. Today, Mike manages the golf course at Okolona Country Club in Mississippi.

JASON STAMER

U.S. ARMY, 1995–2015

Oil on stretched canvas, 36" X 48"

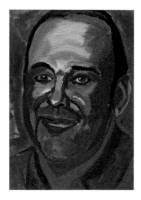

In 2011, both Jason Stamer and his son were deployed to Afghanistan—but a week after his son arrived in theater, Jason was ambushed while on patrol, suffering wounds all over his body. Jason says his recovery has been up and down, but he considers himself lucky to have survived. His wife, Monica, encourages him, making sure he gets the treatment he needs for both his visible and invisible wounds. Part of that treatment includes golf, and Jason has worked to bring a Salute Military Golf Association chapter to Fort Hood, Texas, to help other veterans with their physical and mental well-being.

FIRST LIEUTENANT

MELISSA STOCKWELL

U.S. ARMY, 2002–2005

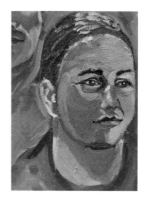

[See page 151 for profile]

SPECIALIST

MARCO VASQUEZ

U.S. ARMY, 2001–2004

Oil on stretched canvas, 48" X 60"

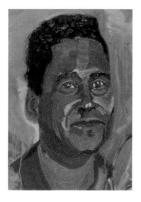

Five years after Marco Vasquez completed his service in the Army, he was diagnosed with PTS and TBI. What Marco saw in combat left him scared, angry, and at times ashamed. Without the resources to properly deal with his invisible wounds of war, Marco struggled with substance abuse and drifted from job to job. Thankfully, his wife's support never wavered. Today, Marco has embraced sobriety and is living a joyful life thanks to mindfulness and meditation—what he calls an "Eastern approach" of alternative forms of therapy that he encourages other veterans to consider.

SERGEANT

JUAN L. VELAZQUEZ

U.S. ARMY, 2006–2012

Oil on stretched canvas, 48" X 60"

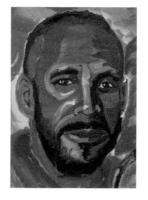

As a combat engineer in the Army charged with patrols and route clearance, Juan Velazquez suffered a number of injuries from IED blasts during his six-year career. While receiving treatment for physical wounds, PTS, and TBI, Juan was introduced to the game of golf, which helps drown out the flashbacks from combat and the second-guessing about whether he could have done anything differently. More important to Juan's recovery, he accepted the Lord as his Savior and looks to Him during his struggles. He credits his wife and children for inspiring him to be a better man.

STEVEN WININGHAM II
U.S. NAVY, 1996–2016
Oil on stretched canvas, 36" X 48"

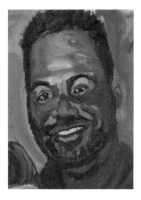

Steven Winingham was shot by an AK-47 in Iraq in 2006, ten years after he joined the Navy. The bullet couldn't be safely removed, so it remains lodged near his spinal cord to this day. Yet remarkably, just seven days after being shot, Steven returned to the battlefield. Years later, Steven recognized that the wounds had taken a toll, so he sought treatment at Walter Reed and was diagnosed with TBI and PTS. Steven has recovered well. He recently earned his MBA and retired from active duty after an honorable 20-year career in the military.

JOHNNIE YELLOCK
U.S. AIR FORCE, 2007–2013
Oil on stretched canvas, 36" X 48"

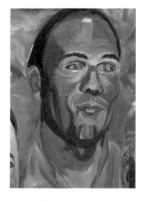

When Johnnie Yellock's vehicle struck an IED in Afghanistan on July 6, 2011, Johnnie did his job as an Air Force combat controller and directed medevac helicopters for his team despite having nearly lost both legs in the blast. After more than 30 surgeries, Johnnie was able to keep his legs—though he will wear braces for the rest of his life. Shortly after his injury, Johnnie addressed a group of top military brass and discovered the positive impact he could have by sharing his story. He encourages other veterans through public speaking and recently started a career in the insurance industry.

LESLIE ZIMMERMAN
U.S. ARMY, 2001–2004

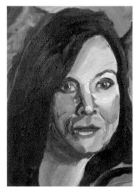

[See page 26 for profile]

ACKNOWLEDGMENTS

In his essay "Painting as a Pastime," Winston Churchill said, "Happy are the painters, for they shall not be lonely. Light and color, peace and hope, will keep them company to the end." Churchill was right. Fortunately, I've also had plenty of people to keep me company as I've worked on this project.

Laura has been a patient and enthusiastic supporter of my new hobby. Without her prodding, I doubt I would have ever picked up a paintbrush. And without her good eye and gentle critiques, my paintings would not be ready for public consumption. I am thankful that in art we have another shared interest, especially late in life. I am grateful for my wife's loving encouragement of my latest pastime—and of all my pursuits over the years—and for the foreword she wrote for this book.

I attempted to give proper thanks to my art instructors in the introduction, but I'll try again here for good measure. Gail Norfleet, Jim Woodson, and Sedrick Huckaby: You have given me a great gift. Thank you for teaching me to paint and to enjoy art.

I am touched that my friend Pete Pace wrote a foreword to this book. General Pace was the sixteenth Chairman of the Joint Chiefs of Staff and the first Marine ever to hold the position. He is a brave man with a big heart. I thank Pete along with Katie Haddock on his staff for helping set the tone of this book.

A special thanks goes to my collaborator on this book, Freddy Ford. Freddy coordinated all aspects of this endeavor while serving as my Communications Director and Personal Aide. He is a smart, funny, and kind man. I am fortunate to have Freddy by my side and grateful for all he did to help me put *Portraits of Courage* together.

For the third time, I had the good fortune to work with Crown Publishing, led by Maya Mavjee, Tina Constable, and David Drake. From start to finish, Tina and David have demonstrated boundless enthusiasm for this project and its purpose. The book would never have made it to market without their energy and support, and I am grateful for the resources they devoted to *Portraits of Courage* and to our military and veterans. In particular, I thank editor Derek Reed, who kept this project moving and whose deft edits made this book better. Marysarah Quinn put together a beautiful product and made the paintings look as good as they possibly could. Thanks as well to the many others at Crown whose efforts went into this book, including Amy Boorstein, Carisa Hays, Donna Passannante, Derek Gullino, Linnea Knollmueller, Dan Zitt,

Neil Spitkovsky, Alexandria Martinez, Kelli Tokos, Sally Franklin, Angelin Borsics, Ayelet Gruenspecht, and Aja Pollock.

I am yet again indebted to Bob Barnett. Bob is not only a fine attorney and effective advocate, but a friend. My profits from this book will benefit our efforts at the Bush Institute, which includes a Military Service Initiative you can learn more about on the following page. I thank Bob's firm, Williams & Connolly, for providing their services pro bono to support that work.

My longtime Chief of Staff, Mike Meece, has managed the team at the Office of George W. Bush since I left the White House. I thank the members of our team, including Logan Dryden, Maria Galvan, Caroline Hickey (with help from Lyric Winik), Harrison Horowitz, Caroline Nugent, Christina Piasta, Madeline Rice, Carol White, Tobi Young, and Cliff Zimmer for their contributions.

Even though I have spent time with each warrior in these pages, none sat for their portraits. I painted from photographs taken by Laura Crawford, Eric Draper, Grant Miller, Paul Morse, and Layne Murdoch. I am particularly grateful to Grant Miller Photography for photographing the paintings for the book.

I thank the fine people who work at the George W. Bush Presidential Center, led by President and CEO Ken Hersh, for their contributions to this project and to the special exhibit of these paintings opening in March 2017: Holly Kuzmich, Executive Director of the Bush Institute; Hannah Abney, Brittney Bain, Brian Cossiboom, Ashley McConkey, Amy Polley, Andrew Kaufmann, and Kevin Sullivan. Retired Army Colonel Miguel Howe is the director of the Bush Institute's Military Service Initiative and is ably assisted by Colonel Matt Amidon, a reservist with the Marine Corps; retired Marine Corporal Jeff Cleland; Jennifer Welty; and Emily Casarona. As the person who helps us keep in touch with the warriors who participate in our Institute's events, Emily spent untold hours tracking down, confirming, and fact-checking important details for this project. With key assists from Natalie Lomont, she did so joyfully and effectively, and I thank her.

Most of all, I thank from the bottom of my heart the courageous men and women who have worn the uniform of the United States. They volunteered to defend our freedom. I will never have an honor greater than looking Soldiers, Sailors, Airmen, and Marines in the eye and saluting them as Commander in Chief. I will never forget those who made the ultimate sacrifice on the front lines and their families. And I will never stop working to honor and help our military, their families, and our veterans. Thank you for reading this book and supporting that mission.

GEORGE W. BUSH
INSTITUTE

The pages of this book contain the stories of warriors who volunteered to wear the uniform of the United States, who served courageously in Iraq and Afghanistan, and were injured in the line of duty. The men and women highlighted in *Portraits of Courage* are just 98 of the approximately four million post-9/11 veterans—each of whom have unique experiences and goals for their lives back home.

President Bush and the Bush Institute are committed to our nation's responsibility to support these veterans and their families. As they transition from their military careers into civilian life, some will face challenges including unemployment, homelessness, feelings of isolation, and symptoms from the visible and invisible wounds of war. In addition to these burdens, research shows a civilian-military divide: most Americans say they have little understanding of the issues facing veterans, and the vast majority of veterans agree.

At the Bush Institute, we believe that knowing our vets is the first step to honoring their service and sacrifice. To that end, we've developed a library of resources for both civilians and veterans at www.bushcenter.org that help bridge the gap. In addition, here's how citizens who want to help can be a part of the solution:

• Change the way you think about invisible wounds of war like post-traumatic stress and traumatic brain injury, taking care to eliminate any preconceived ideas or stigma. Understand that with effective treatment and support, these injuries can be overcome.

• Take the time to understand the issues facing veterans in your community, and share what you learn with others.

• Hire, develop, retain, and support veteran employees and their spouses.

• Learn about and support—with your time or your money—effective organizations that help vets.

• If you know a veteran who is transitioning out of military service and needs support, encourage them to visit bushcenter.org to find resources that will help.

America can never fully repay our veterans, but we must try. The most important way to do so is to recognize their service in the military as a formative experience in their lives and a source of skills and values that prepare them to succeed in civilian life. By supporting and enabling our Nation's warriors in their new missions, we unleash the potential of a generation of resourceful, determined, and experienced leaders—for the good of our vets, and our country.

To learn more, visit
WWW.BUSHCENTER.ORG